DATE DUE

DEMCO, INC. 38-2931

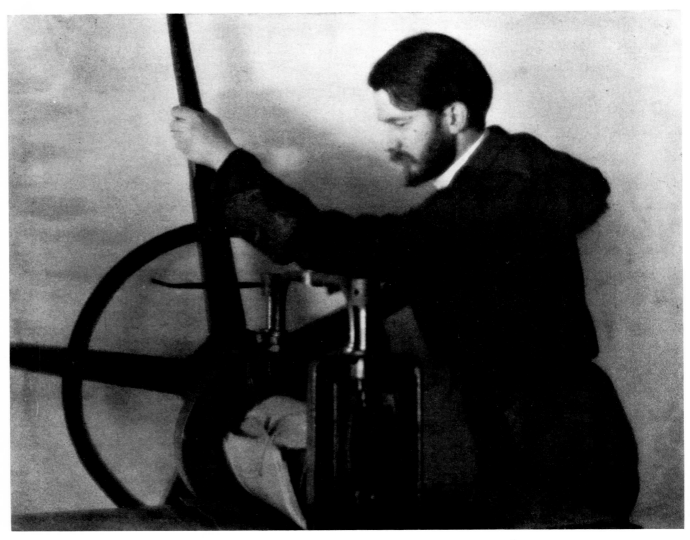

Self-portrait of Alvin Langdon Coburn with copper-plate printing press. 1908

Alvin Langdon Coburn
Photographer

AN AUTOBIOGRAPHY WITH
OVER 70 REPRODUCTIONS OF HIS WORKS

Edited by Helmut and Alison Gernsheim
With a New Introduction by
Helmut Gernsheim

DOVER PUBLICATIONS, INC.
NEW YORK

Published in Canada by General Publishing
Company, Ltd., 30 Lesmill Road, Don Mills,
Toronto, Ontario.
Published in the United Kingdom by Constable
and Company, Ltd., 10 Orange Street, London
WC2H 7EG.

This Dover edition, first published in 1978, is
an unabridged republication of the work originally
published by Frederick A. Praeger, Publishers,
New York, in 1966. New in this Dover edition are
the Introduction by Helmut Gernsheim and the
last five photographs (Nos. 65–69).
The publisher is grateful to the International
Museum of Photography in Rochester, and espe-
cially to Mr. Jeffrey A. Wolin, Supervisor of its
Photographic Reproduction Center, for supplying
new glossy prints of most of the illustrations
for reproduction in the present edition.

International Standard Book Number: 486-23685-4
Library of Congress Catalog Card Number: 78-55345

Manufactured in the United States of America
Dover Publications, Inc.
180 Varick Street
New York, N.Y. 10014

Introduction to the Dover Edition

TWELVE YEARS HAVE PASSED since this book first appeared in print. By a great effort Alvin Langdon Coburn lived to see its publication and passed away contentedly clutching the volume in his hands, on November 23, 1966. He was in his eighty-fifth year.

It now seems appropriate to add a few personal notes about the grand old man and the circumstances that led to our collaboration. I had corresponded with Coburn irregularly for a number of years before we actually met. The occasion was his lecture on October 22, 1957 at the Royal Photographic Society, at the time of his unexpected reemergence as a photographer after decades of self-imposed retirement. The following day, over lunch at our apartment on Regent's Park, my wife Alison and I really got to know the shy recluse from Wales.

Coburn was an introvert by nature, I believe, but the recent loss of his greatly beloved wife Edith had turned him into a hermit spending his time in meditation and in the service of Freemasonry. Though I plied him with questions, I had the feeling that he was not eager to talk about his brilliant career that had made him famous as a young man. His youthful vitality and keen ambition, which had propelled him to fame in a relatively short time, seemed all spent. Coburn's mind was set on another world.

And yet, as I soon found out, there was still one strong desire agitating his mind to bring the last touch of fulfillment to his life. He told me that he greatly admired my monographs on Julia Margaret Cameron and Lewis Carroll, whose portraits had been a great inspiration to him quite early in his career, as they had been in mine. Our mutual appreciation of the great masters of Victorian photography, and my admiration for many of Coburn's own pictures, cemented a bond of sympathy between us. Coburn was also delighted to notice my keen interest in his most recent work, for I had been rather critical of his outmoded soft-focus illustrations to R. L. Stevenson's *Edinburgh*, published a few years before. An exchange of ideas, Coburn suggested, would create the ideal condition for getting to know and understand each other's viewpoint, and would lead to friendship. Perhaps I might then feel in the right mood to consider sympathetically a plan he had carried in his mind for some time, and which his late wife had very much encouraged.

Looking him straight into the face, I asked in what way he felt I could serve him. "Knowing that my work is concluded," he replied, "I would like to entrust it to

able hands to create something fresh with it. I am getting old and I have neither children nor close relations. My work will be dispersed one day, but before I die I would like to see a monograph published. That would give me something to live for and make me happy. I can't think of anyone to write a biography with the expertise you have shown in your various monographs. And you would not have to spend any time on research, for I would place all the material at your disposal."

Though I felt greatly honored and flattered, I was nevertheless rather taken aback at this unexpected suggestion. My experience with contemporary photographers in *The Man Behind The Camera* had shown me the difficulties such a collaboration can entail: restrictions in the choice of material, involvement in long discussions, the need for persuasion, concessions and endless delays. In the end the editor has to write the entire work himself to meet the publisher's deadline. I did not relish the prospect. Another reason for my not wishing to get involved with this project was my inability to accept without reserve the self-conscious pictorialism of the Art Nouveau period in general and my distaste for the soft-focus mania in particular. The latter was not only untrue to nature, but it also destroyed the essential qualities of the medium. Coburn was undoubtedly an experimenter and innovator in many respects, but was not Paul Strand, his American contemporary, a far greater avant-garde artist? Paul had broken with nineteenth-century conceptions of photography and ushered in the twentieth with quite novel ways of seeing and expressing. Given the choice, would I not rather produce a study on Paul, who more than once had invited us to stay with him and Hazel at Orgeval?

These thoughts dashing through my mind made me momentarily oblivious of the fact that I was not even free to consider my friend's proposition. Having suitably thanked him for the honor of selecting me as his biographer, I explained that my various book, exhibition and television engagements unfortunately prevented me for two or three years from taking on any new engagements. However, I could undertake the task, but only if he was prepared to grant me complete freedom in the selection of the photographs, correspondence and published writings. As Coburn readily agreed, I suggested that he might meanwhile draft an outline of his life and credo or goal in photography, reminiscences of his meetings with Shaw and other great men, and prepare the source material. This would greatly enhance our future collaboration, for he no doubt appreciated that I could not leave my collection for a lengthy stay with him in Wales. My new concept of the book as an autobiography was in his own interest as much as in mine, I went on, for it was bound to arouse deeper public interest than the best pen portrait by someone else. I agreed to look after the editing and polishing, and on this happy note of mutual understanding we parted.

Six years passed by. Alison and I were a great deal abroad with our exhibition and had only recently returned from a six months' stay in the United States when Mitchell Kennerley, a director of Faber & Faber Ltd, asked me to see him. They

were the publishers of my *Creative Photography* and now had my wife's *Fashion and Reality* in the press. He informed me that Coburn had submitted some auto-biographical notes and a number of articles the photographer had published from time to time. This was useful source material for an editor and ghost writer, yet quite unpublishable as it stood. Fully aware of this fact, Coburn had told Kennerley of his conversation with me in 1957, suggesting that the material be handed over to me with the request to turn it into book form. Kennerley had also received sixty-four photographs which he wanted to pass on to me.

I explained that his request caught me at a most inopportune moment, for I had just signed an agreement with Thames & Hudson Ltd for *A Concise History of Photography* and had on top of this to prepare an inventory of the Gernsheim Collection for the University of Texas, which had recently acquired it. From October onward the shipping agents were to collect the material in weekly installments for packing. Under these circumstances both he and Mr. Coburn would no doubt appreciate our inability to take on any additional work. If I considered the material adequate for a monograph, at least twelve months would have to pass before my wife and I would be free to start work on it. Alternatively he might wish to entrust it to someone else. Kennerley, who had published two of Coburn's books in New York before World War I, understood my position. As far as Faber & Faber were concerned, he assured me, the delay would not matter. Yet he thought it best for me to talk the problem over with Coburn and to obtain his agreement to this and any changes I proposed to make in his text and selection of photographs.

I read the typescript on my journey to Coburn's home on Colwyn Bay on October 18, 1963. Coburn's reminiscences were largely disjointed notes on this and that, presenting no continuous life story that one could polish. The book, in fact, had still to be based on the notes, incorporating the excellent source material that appeared in several appendices. This would have to be enlivened with excerpts from corre-spondence with Shaw, H. G. Wells, Henry James and other authors, which Coburn had overlooked to my surprise. To turn these bits and pieces into an autobiography would probably take us half a year, and the 200 pounds Kennerley had offered for the "editing" seemed paltry for the time involved. I decided not to get involved. Coburn was waiting for me at the station with his car. At 81 he was a surprisingly good driver and on our way to his house "Awen" at Rhos-on-Sea he wanted to hear my impressions of America, with details of our exhibition in Detroit, of our meeting with Steichen and Beaumont Newhall, and of the astonishing news he had heard from Kennerley that my collection was going to Texas.

Later, at "Awen," he told me how sorry he was that his book project came at such an awkward moment for me. Naturally he would wait until we were free to give our attention to it. He was delighted that I had come despite the great pressure of other work, for now he could at least consider my suggestions. He had complete confidence in my handling of his biography. My last book, *Creative Photography*,

had been a source of enjoyment in his loneliness. "I am glad you feel I made a lasting contribution to the art, even if my portraits lack the precision of Bellini," he added with an impish side glance at me. I had never seen Coburn so animated. His usual withdrawn, quiet manner with long silences was suddenly gone. He shot his sentences out like an excited schoolboy tasting the pleasure of his first holiday back home.

My suggestion that the fine text contributed by Nancy Newhall for the portfolio of plates published by George Eastman House the previous year, constituted a lasting monument to him, hardly to be improved upon, fell on deaf ears. Coburn had set his heart on a full-length biography, and it was clear that no discussion could make him waver from his resolution. "Tomorrow I will show you all the photographs I have and copies of some of the letters you wish to see. You have carte blanche to use or reject anything. I won't interfere. I am entirely at your service. I have only two reservations to make. The photograph of Edith which you don't care for [Fig. 3] I would like to remain. She was the best companion I can think of throughout the productive years of my life and I got nothing better of her. This is her as I shall always carry her in my heart. The other request concerns layout. I would like to avoid two photographs facing each other. The text should fill the left-hand pages and the plates—Kennerley specified sixty-four full-page ones—should appear on the right-hand side." I consented in the name of the publisher, provided the length of the text enabled this idea to be carried through to the end of the book.

Coburn was happy and seemed rejuvenated by his enthusiasm. His terms of collaboration were so generous that I did not find the courage to dampen his spirits by backing out from the project—though a few hours earlier my resolution had been firm.

The next day I made a new selection of photographs, avoiding as far as possible any of the sixteen plates that had been published in the George Eastman House portfolio. Some of these have now been added to the Dover edition. As Coburn had been just as famous for his landscape work as for his portraits, my suggestion to reproduce two groups of thirty-two plates each met with his approval. Failing to find GBS in the nude after Rodin's "Le Penseur"—a picture which I vaguely remembered having seen reproduced in a posthumous collection of portraits of Shaw—I enquired whether he couldn't find it. "Oh yes, it's here all right, but I don't want to publish it. It was a joke between Shaw and me. In 1906 he was very amused by the Press comments it aroused when exhibited, but now he might think differently about it, if he were alive." "Shaw always had a good sense of timely publicity," I countered; "he needed it then, and you need it now. If you have the right to publish it, let's have it. Reviewers of the book will love it. They never know what to write about art photography, but if we lay a bait they will swallow it." The picture was produced, and the press did not let me down.

After the photographs we tackled the correspondence prepared in typescript. I

was interested to know where the originals were and Coburn replied that they had all been presented to institutions, without specifying any names. For any quotation he would obtain for me the permission of the writer's heirs. The most amusing and prolific letter writer was undoubtedly GBS, but Henry James, H. G. Wells and George Meredith also had their share to contribute. I had no access to any notebooks or diaries; if they existed, which is probable, their present whereabouts is unknown to me. Coburn informed me that he intended to bequeath everything connected with photography to George Eastman House [now the International Museum of Photography] in Rochester. This, I assume, included copies of all his books as well as his large stock of old photogravures. In January 1964 I met Beaumont Newhall when he passed through London on his way to Coburn to settle the bequest, I believe. Coburn's set of *Camera Work* had been presented to Fritz Gruber of Cologne some years earlier.

Coburn's life with his housekeeper, widow of a sailor and a fellow Freemason whom he addressed as "sister," must have been deadly boring. They lived in different worlds and shared no cultural interests. For this reason Coburn was particularly appreciative of any interest shown him by outsiders, apart from the spiritual consolation he found in the Freemason brotherhood. Because his early work had appeared almost exclusively as illustrations to literary publications or in limited-edition portfolios, and his late photographs of 1953–57 were hardly known outside the membership of the Royal Photographic Society, few people knew more than a handful of his pictures and fewer still were aware that the grand old man was alive. His thirty years' disappearance from the photographic scene was largely responsible for his falling into oblivion.

My three days at "Awen" passed very quickly in the interchange of ideas on art, music and photography. I had Edith's room and her comfortable bed and shared Coburn's frugal meals with Mrs. Riddle. As the sifting of the material had made excellent progress, Coburn suggested that we keep the last morning for a drive. It was a beautiful day, and after breakfast he asked me to remain in the dining room; he wanted to take my portrait as a keepsake of my visit. They would probably be his last pictures, he added on a sad note—and I believe they were. He fetched his simple folding Kodak. I sat opposite to him across the table on which he placed the camera, facing the light streaming in through the French window. He snapped away, asking me to vary my position after each exposure. A fortnight later I received eight prints, each three-and-a-half by five inches, mounted and signed. This charming parting gift is now in the Gernsheim Collection at Austin.

Afterwards we drove along the coastal road to Llandudno, where he pointed out to me the house, now a hotel, at which Lewis Carroll stayed with the Liddell family. We still had time to visit Conway Castle, a majestic ancient fortress, before I had to depart for London. My last impression was of a lonely figure, and a good friend, waving goodbye to me with his cap.

We corresponded fairly frequently until Alison and I moved to Switzerland in March 1965. The previous month I had handed over to the publishers typescript and photographs of the autobiography. Though well ahead of the promised time, the long wait had put a great strain on my friend. His letters had become more pressing and urgent, for he felt he would not live to see the book—and its expectation was all that still sustained him. It was pathetic.

Under great pressure to finish my *Concise History*, I could do no more than advise my wife, who generously took over the Coburn project from me. Alison did, I think, a brilliant job of knitting Coburn's notes and documents, and her own additions, into a homogeneous and coherent biography. The text is a harmonious blend of Coburn and herself, indistinguishable to the reader in keeping the autobiographical character intact.

Unfortunately, Faber & Faber shelved the material for several months until Coburn's patience had reached its limit and our joint work went into production. It was a blessing for all concerned that he did not pass away before he had the satisfaction of seeing his last wish brought to fruition.

HELMUT GERNSHEIM

Castagnola, 1978

LIST OF PLATES

PORTRAITS

I

SUPPLEMENTARY PLATES, 1978 EDITION

**ANDROCLES AND THE LION
OVERRULED
PYGMALION**

A Hun who was shouting down Holborn
That Deutschland muss Alles erobern
Was snapped in the act
With remarkable tact
By Alvin + Langdon + Coburn.

to Coburn
from Shaw

Harlech
18/4/21.

Fig. *1*. MS Limerick by G. Bernard Shaw, 1922 in presentation
copy of *Androcles and the Lion*

DEDICATION

I dedicate this book to those who in my later life have helped me on my way, who have enabled me to live more richly and fully, and whose friendship I greatly value.

There are Beaumont and Nancy Newhall, to whom I owe the publication of my Portfolio by George Eastman House, and many other kindnesses; there is Norman Hall, who was instrumental in introducing my photography to many new friends; Professor Donald Gordon of the University of Reading, who made possible my exhibition at that seat of learning; Leonard and Lena Arundale, who encouraged me to persevere in the writing of this book; James Massey, who makes my garden beautiful; and my colleagues in Freemasonry and other kindred mysteries. These I thank, and to them I proffer this dedication.

I am very grateful to my friend Helmut Gernsheim for helping me choose the illustrations and for suggesting the form this book should take, and to Alison Gernsheim for selecting excerpts from my notes, published writings, and broadcasts, and arranging them into a continuous narrative. To have the assistance of experts was a great advantage, and avoided the undue influence of personal considerations.

Above all, I express my deep appreciation of Sarah Riddle, who has made my later years rich in contentment through her administration to my comfort. To her this dedication is most especially directed.

There are others who for personal reasons I am unable to mention by name, but they are nonetheless remembered in my appreciation and thanks.

ALVIN LANGDON COBURN

FIRST AND LAST THINGS

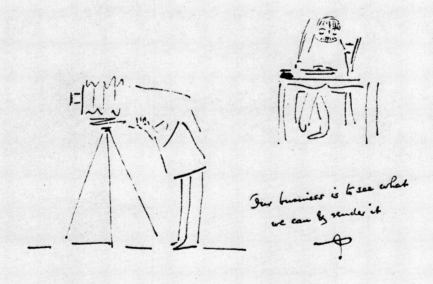

Fig. 2. Drawing of Alvin Langdon Coburn by H. G. Wells
in presentation copy of *First and Last Things*

7

CONTENTS

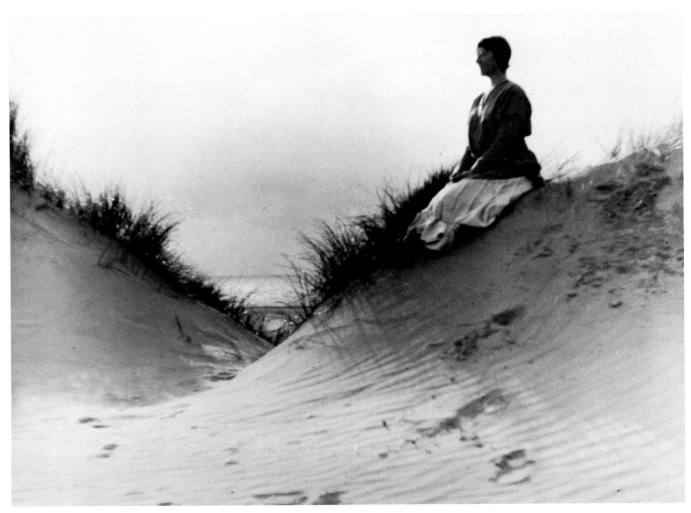

Fig. 3. Edith Wightman Coburn, 1922 *(See page 88)*

I. Early Days

"ONCE UPON A TIME there was a small boy named Alvin"—this is the way that all proper fairy-tales begin, and I like to think that there is something of the mystery of the fairy-tale in the unfolding of my own life.

I was born on 11th June 1882 at 134 East Springfield Street, Boston, Massachusetts.

One of my earliest recollections is the treasured possession of a brightly coloured iridescent dried beetle, which I kept in a small mustard tin. How I was allowed to have such a treasure I can hardly imagine, but the fact that I did possess it is so deeply impressed on my memory that I am convinced of its truth. Perhaps I was able to keep this a secret?

Coupled with the beetle memory is my earliest romance, that with my first nurse-maid Bella, who was very beautiful. She was Swedish, tall, slender and graceful, with golden hair and charming blue eyes. I loved Bella very much and promised myself that when I grew to manhood I would marry her. I never lost the childhood fragrance of this memory.

When I was five years of age we moved out from Boston to a suburb, Dorchester. Here we lived in a big old-fashioned wooden house on a hill, surrounded by horse-chestnut trees. In the garden I had a little playhouse all my own, where I spent many happy hours day-dreaming.

I had a large dog, a red Irish setter, who was very affectionate and insisted on putting his paws on my shoulder and in consequence often sent me sprawling. This was a little distressing for a small boy, but I held him in no animosity, for I knew that he meant well and was really very fond of me.

My father, whose firm Coburn & Whitman manufactured shirts on a profitably large scale, died when I was seven years old, and I was shown his body lying in the coffin in a bank of flowers. This was a sight I shall never forget, and I do not think a young and impressionable child should ever be presented with the spectacle of Death.

Soon after the passing of my father we went to stay with my mother's family in Los Angeles, three thousand miles from Boston. I remember my grandmother lived in a rose-covered wooden cottage sandwiched between two tall office buildings.

At that period, long before the "movies", Hollywood was literally a holly wood,

and was reached from Los Angeles by a street car drawn by a mule. There was only one tram, and when it got to the end of the journey, it turned round and came back again.

If my mother had been gifted with a vision of the future and bought an acre of land there—which could have been acquired for a song then—the result would have been fantastic. So much for dreams and visions, but perhaps I am happier as I am with my adventure in photography? This began on my eighth birthday, when two of my Californian uncles gave me a $4'' \times 5''$ Kodak, which had to be loaded in a dark room with a roll of film for forty-eight exposures. The shutter was set by pulling out a piece of cat-gut with a round button on the end of it, the release of which produced the exposure. It had only one speed, and that was not very fast. My first picture was of the neighbour's dog, a friendly little animal who wagged his tail at the moment of exposure so that the result resembled a fan where there should have been a tail, which pleased me greatly.

My maternal grandfather, Joseph Howe, and his family had travelled in a covered waggon over the plains from Cincinnati, Ohio, in the Middle West to California in the 1849 Gold Rush. They did not find gold, but bought property in what subsequently became the centre of Los Angeles, and this eventually proved equally valuable.

My father's ancestors spelt their names variously Colbourne, Colburn and Coburn. They were descended from Edward Colburn, an English farmer who was born in 1618, had seven sons and two daughters, and died in 1712.

When I began to look up my forebears in 1916 I was not sure where this Edward, who emigrated to America, was born, but there was a family tradition that he came from near Devizes in Wiltshire. I therefore wrote to the Town Clerk of Devizes, and he put me in touch with an expert genealogist, who informed me that about the year 1700 there were a number of Colburns in the church register of the village of Lacock, not far from Devizes. When I went to investigate in person, the vicar was kind but not very hopeful, having often been pestered by ancestor-hunting Americans in the past. On inspecting the register, however, he found the very entry I required. He was so pleased that he invited me to tea and gave me an enthusiastic "welcome home" after an interval of ten generations!

I found no living Colburns in Lacock, but plenty of their tombs in the church-yard, and discovered that Edward Colburn left for the New World as a child about 1630, only ten years after the Pilgrim Fathers. He settled in Dracut, Massachusetts, and there is a complete record of his descendants up to my own entry in the Coburn Genealogy compiled by Silas Coburn and published in 1913 by Walter Coburn in Lowell, Massachusetts.

The ancient Lacock Abbey was the birthplace of Fox Talbot, the inventor of photography on paper, and the unspoilt picturesque village, in which practically every architectural style since the thirteenth century is represented, was owned and

12

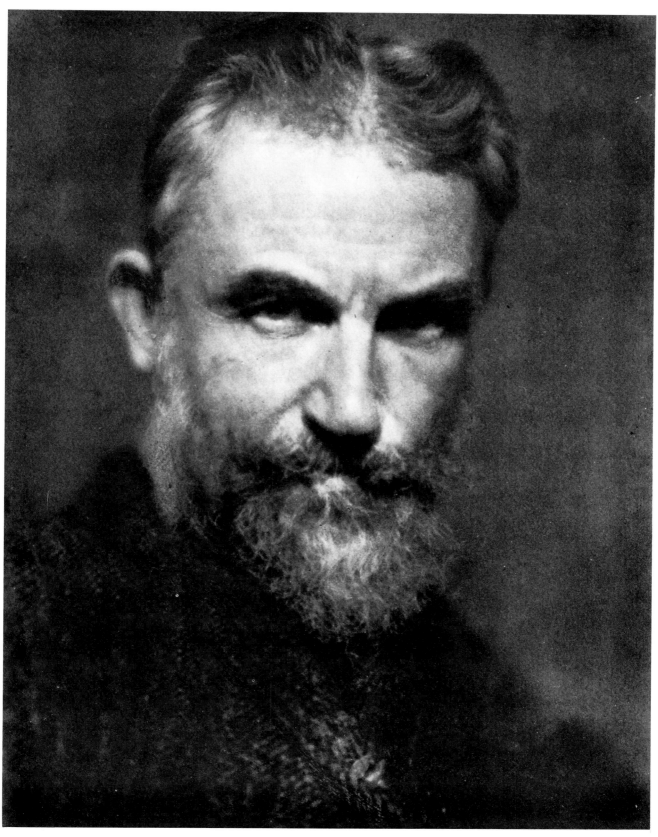

1. George Bernard Shaw. 1904

well cared for by the Talbot family for three and a half centuries, until presented by Miss Matilda Talbot to the National Trust in 1944.

In 1891 my mother and I returned from Los Angeles to Dorchester. During all my time at the Chauncey Hall School I kept my interest in photography. When I was fifteen my mother and I moved to Boylston Street, Boston, where I had a studio and hung my photographs.

It was in the year 1898 that I first met F. Holland Day, a distant cousin who had a considerable influence on my becoming a photographer. An enthusiast for the writings of Keats, Maeterlinck and Edward Carpenter, Day was a cultivated and sensitive man of independent means who published books as a hobby. I already knew of his work and especially his photographs of sacred subjects in which he posed himself as Jesus, letting his hair and beard grow for over a year in the manner of the Oberammergau Passion players, as a measure of his enthusiasm and sincerity. In his house on elegant Beacon Hill Day used to exhibit his photographs in an incense-laden atmosphere to the *élite* of Boston society. To this shrine I went one day, climbing steep and romantic stairs to gaze in awe and wonder at his master-pieces. I was armed with a small portfolio of my own photographs—prints which must have evinced a certain promise of talent, for some time later my cousin suggested that my mother and I should accompany him to London, where he was planning to hold an exhibition entitled "The New School of American Pictorial Photography".

London at the turn of the century was a very attractive city, and at seventeen I was eager for experience and full of enthusiasm; fortunately my father had left us sufficient for independence. Accordingly we crossed the Atlantic in the summer of 1899 in a slow-moving liner, and took rooms in Guildford Street, Russell Square. Day rented a studio and dark-room in Mortimer Street. Up to this time Day had all his developing and printing done by others, but now under my guidance he learned to do it himself. In this I became the teacher and he the pupil. To be in the company of this intellectual and artistic man was an education in itself, and it was thus that I really began my career as a serious photographer.

Edward J. Steichen—now at eighty-six the doyen of photography—was in London at this time. Even as a young man of twenty-one he was a dynamic personality with promise of his later achievements. I have recently been reading that wonderful book by him, *Edward Steichen: A Life in Photography*, and was proud to see on the back dust-cover a quotation from G. Bernard Shaw in 1912: "Steichen and Coburn are the two greatest photographers in the world." I am sure that he was right about Steichen!

Steichen's talent was immediately recognized by Holland Day, who invited him to contribute to the forthcoming show and assist us in its hanging and presentation. The exhibition, which opened at the Royal Photographic Society, then in Russell Square, on 10th October 1900, consisted of 375 photographs including 103 by

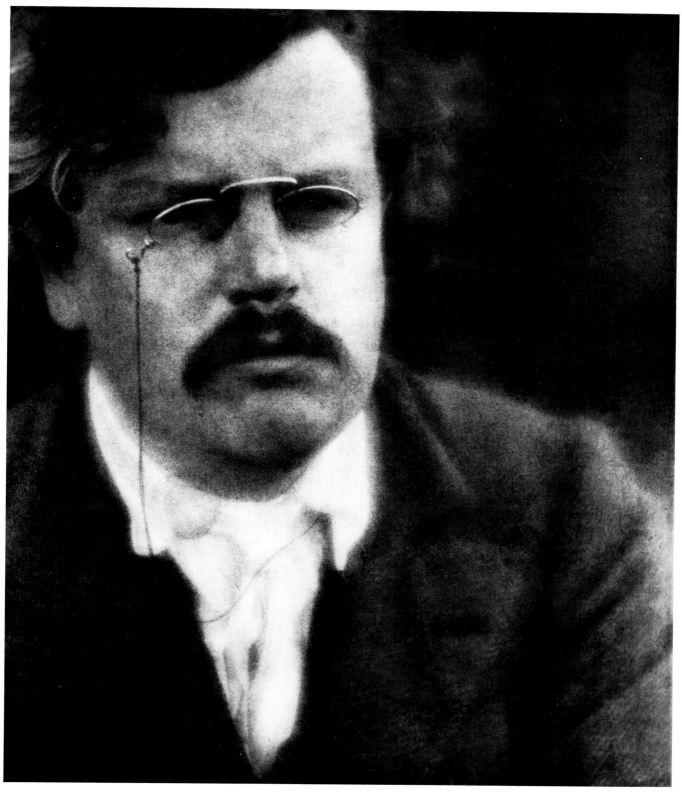

2. Gilbert Keith Chesterton. 1904

F. Holland Day, 21 by Steichen and 9 by myself. There was also at the same time a rival exhibition—the annual London Salon of Photography organized by the Linked Ring, a secession from the Royal Photographic Society. They showed some of the most advanced work that had been seen up to that date. Three of my photographs were hung in this leading international exhibition.

During this first visit to London I met Day's friend Frederick H. Evans, renowned for his platinum prints of cathedrals and other architecture. He was a retired bookseller of character, who used to sell his customers what *he* thought was good for them, instead of what they had come in to buy!

Through Day and Evans I met many other well-known British photographers. All this was a most valuable experience for me at the beginning of my photographic career.

Early in the New Year my mother, Holland Day and I went to Paris, where Day showed his exhibition at the Photo-Club. Steichen, who was painting and photographing in a studio in the Boulevard du Montparnasse on the Left Bank, made us very welcome, as was also Frank Eugene, another talented American photographer whose real name was Frank Eugene Smith. Frank Eugene's photographs were wonderful. He worked on his negatives with a graver, which made them look like etchings.

From the vantage point of the big balcony in Steichen's studio I made a series of exposures of Day, Steichen and Eugene, looking down upon them from above.*

The Latin Quarter was at that period a place of romance. You could dine at little restaurants where artists, afterwards famous, paid for their meals by painting mural decorations on the walls! There were smaller cafés where you could get coffee with whipped cream in settings which were period pieces of life in a truly artistic background. Here our little party of photographers gathered together and enjoyed ourselves to the full, for we were young and carefree and life was richly flavoured.

While in Paris I met Robert Demachy, founder of the Photo-Club de Paris and leader of the aesthetic movement in photography in France. Demachy, a banker, was an aristocrat and lived in a stately mansion, but he was not at all snobbish and mixed with our American contingent on equal terms. He and his friend C. Puyo, an officer, both made remarkable gum prints in the impressionist style, some of them bearing a close resemblance to Degas pastels. Now I must confess that I do not approve of gum prints which look like chalk drawings, nor of drawing on negatives, nor of glycerine-restrained platinotypes in imitation of wash-drawings as produced by Joseph T. Keiley, a well-known American photographer and a friend of Alfred Stieglitz. Nevertheless, I do not deny that Demachy, Eugene, Keiley and others produced exciting prints by these manipulated techniques, which differentiated them from the ordinary run of amateurs who in the 1880s and '90s inundated the world of photography in their hundreds of thousands after the introduction of

* Published in *Photo-Era*, July 1902.

16

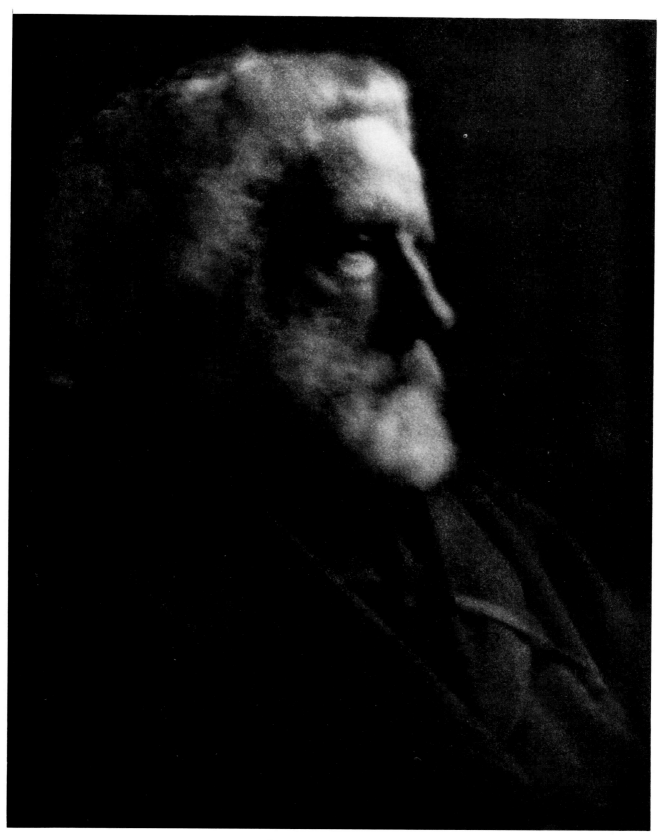

3. George Meredith. 1904

factory-produced dry plates (and from 1889 onward celluloid roll-film) and simple hand-cameras had removed the necessity for any particular skill. In most of the so-called controlled processes it was possible by manual treatment of negative or print to create a hybrid of graphic and photographic art. This I rarely did, for I am myself a devotee of pure photography, which is unapproachable in its own field. The combined gum-platinum printing process which I used for some years, though complicated, was purely photographic. My only concession to the taste of the time was the use of a soft-focus lens, made especially for me by my friend Henry Smith of Boston.

In the gum-platinum process the first step was to make a platinum print, which could be either in the normal silvery-grey colour, or toned to a rich brown by the addition of mercury to the developer. The finished print was then coated with a thin layer of gum-bichromate containing pigment of the desired colour. I found Vandyke brown especially suitable owing to its transparency, and by having the underlying platinum print in grey, a very pleasant two-colour effect was produced. The bichromated print was replaced behind the original negative, great care being taken to get it accurately in register. It was then re-exposed and developed in the usual way.

It was in the nature of platinum prints that the shadows were somewhat weak; by superimposing a gum image they were intensified. The whole process added a lustre to the platinum base comparable to the application of varnish, at the same time preserving the delicacy of the highlights in the platinum print. If the shadows were still not deep enough, a second coating of pigmented gum, or even a third, could be added and the print re-exposed, but with skill and practice one coating of gum was usually sufficient.

To my regret, platinum paper was no longer manufactured after World War I, for it gave very delicate gradations of tone and had the advantage of absolute permanence.

After a tour through France, Switzerland and Germany, my mother and I returned home to Boston in 1901.

My mother was a remarkable woman of very strong character, who tried to dominate my life. To this I had serious objections, so I retired into my own hidden self and there built up my defences, and it was battle royal all the days of our life together. Yet in her own way she loved me deeply. My mother was married three times, my father being her second husband. I think he loved her more than she loved him. Her third husband came, of course, in my own time, and I made his life fairly miserable, I am afraid.

In 1902 I opened a studio in Fifth Avenue, New York, my main purpose being to show my photographs. I never had a commercial portrait studio. This establishment was not far from Steichen's studio at No. 291 Fifth Avenue, which in 1905 became the new quarters of Alfred Stieglitz's Photo-Secession. Stieglitz (Plate 16), who from 1892 onward made memorable photographs, especially of street scenes

4. Edward Carpenter. 1905

in New York, shared with Holland Day the aspiration to the leadership of the American School, and they were, I think, a little jealous of one another. Stieglitz had refused to take part in Day's exhibition at the Royal Photographic Society. He already enjoyed high prestige in the world of international photography, and when on 26th December 1902 I was elected a member of the Photo-Secession, which he had recently founded, I was delighted. From 1903 to 1917 Stieglitz edited *Camera Work*, in my opinion the most beautiful photographic magazine ever produced. The illustrations were mostly photogravures on Japanese paper, reproduced with the utmost care and fidelity. It was a unique production and I am proud to think that three issues* presented examples of my work.

A number of my prints were shown by Stieglitz at his "Little Gallery" at "291" on various occasions, including two one-man shows, of 53 prints in 1907, and 33 prints and 20 Autochrome colour photographs in 1909.

When I began my career photography was hardly considered as an art, or a photographer as an artist. It had its battle to fight and win, but it was to achieve victory by virtue of its own merits—by the unique subtlety of its tonal range and its capacity to explore and exploit the infinite gradations of luminosity, rather than by imitating the technique of the draughtsman. Stieglitz with sincerity and devotion dedicated himself to promoting the recognition of photography as an art, and he was also a connoisseur of modern art. With the assistance of Steichen he exhibited at "291" the work of many now famous artists for the first time in the U.S.A.

In addition to membership of the Photo-Secession, I was elected a member of the Linked Ring in London on 21st November 1903. So, at the age of twenty-one, I was active in the two most advanced and artistically conscious groups of internationally-known photographers.

It is best, I think, to take up photography when you are quite young, though eight, as in my case, is perhaps unnecessarily immature! Proficiency in any art is acquired by complete familiarity with its technique, and this is best achieved when the mind and body are young and flexible. Technique is thus built into the mind and becomes automatic—a matter of natural reflex actions, leaving the mind free to devote itself to the really important matter: direct contact with what we wish to express. The camera should become a part of the very existence of the user. There should be no fumbling or uncertainty, but a sureness and mastery of the complexity of the instrument that will leave the mind free to grasp the importance of the feeling nature has flashed to the brain of the artist.

After the spontaneity of the creation of the negative follows the sustained effort of developing and printing, and no-one save he who has spent four or five hours peering at things in the dim red glow of a dark-room—which Dante would have revelled in as a bit of local colour for his best-known poem—can realize the effort necessary to achieve good results in our particular medium. It is sometimes a moral

* *Camera Work* No. 6, April 1904; No. 15, July 1906; No. 21, January 1908.

5. Self-portrait of Alvin Langdon Coburn. 1905

as well as a physical effort: the man who spends hours in the dark-room on a sunny spring day when all nature is calling, is nothing short of a hero!

My first one-man show was held at the Camera Club of New York in January 1903. How proud I felt when Stieglitz called my pictures "original and unconventional"! After working for about a year in the studio of Mrs. Gertrude Kasebier, a leading member of the Photo-Secession, I returned to Boston. In 1903 I participated in the Summer School at Ipswich, Massachusetts, directed by Arthur W. Dow, later Professor of Art at Columbia University, New York. At the Summer School we were taught painting, pottery, and wood-block printing, and I also used my camera, for Dow had the vision, even at that time, to recognize the possibilities of photography as a medium of personal artistic expression. I learned many things at his school, not least an appreciation of what the Orient has to offer us in terms of simplicity and directness of composition. Oriental art influenced a photograph called "Sand Dunes" which I took at Ipswich. It was the first of my photographs to be bought by an art gallery for its permanent collection. I recollect how pleased I was at the event, for Alfred Lichtwark, Director of the renowned Hamburg Kunsthalle, was the first official to collect photographs as pictures in their own right.

I think that all my work has been influenced to a large extent and beneficially by this oriental background, and I am deeply grateful to Arthur Dow for this early introduction to its mysteries.

I consider the great Japanese painter Sesshu (1420-1506) one of the finest and subtlest artists the world has ever known, and I am a devotee of the spirit of his work. Sesshu was also a Zen priest and something of its doctrine of non-striving has entered into his work, imbuing it with a spirit not altogether of this world. I hope and believe that something of his influence has crept through my lens into my heart, and there re-expressed itself in terms of my own art of photography. Do I imagine this, or is it possible for an influence to travel through time and space, to enter another era, and another land, and another quite different art, and there take up its abode? I like to think that perhaps this may be so!

I could eat with chopsticks almost as soon as I could with a knife and fork; which reminds me of a Chinese saying that chopsticks are the beak of a bird, but a knife and fork are an animal tearing its food. This is not very complimentary to European civilization. To the Chinese, whose food is so daintily prepared in tiny pieces, it must seem almost like cannibalism to serve portions of an animal's carcase. I still rejoice in "Chow Mein" and "Sweet and Sour", and my collection of Chinese cookery books is large, greatly cherished and frequently consulted.

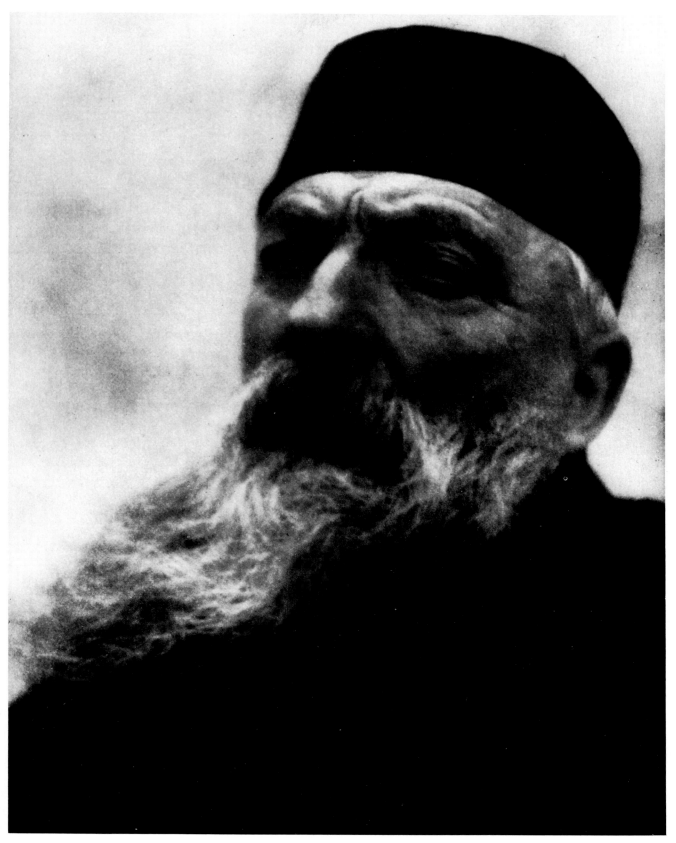

6. Auguste Rodin. 1906

II. Men of Mark

IN THE SPRING OF 1904 I had a very memorable and fruitful interview with Perriton Maxwell, editor of the *Metropolitan Magazine*, New York. I was an ambitious young man on the point of sailing for my second visit to London, and I asked Maxwell to let me have a list of English authors and artists to photograph during my sojourn in the greatest city in the world. Out of the kindness of his heart, or, perhaps, more to get rid of me than anything else, he jotted down the most prominent people he could call to mind. Years later, Maxwell confessed to me that he had not the slightest idea that I would ever get any of them. I had, however, inherited from both my parents persistence and determination to carry anything once attempted to a conclusion. This long-term project resulted in my books *Men of Mark* (1913) and *More Men of Mark* (1922). I regret that the intended third volume *Musicians of Mark*, for which I took thirty-three portraits, never reached the stage of publication.

I have always been deeply interested in consummation in the arts, and I think this was the chief reason why I began making photographic portraits. If I admired the writings or expressed vision of any person, I was impelled by the desire to meet and photograph him. This was the beginning of the urge, and it has remained with me through life.

My portraits are a recording of my appreciation of the artistic achievement of the times in which I have lived.

A photographic portrait needs more collaboration between sitter and artist than a painted portrait. A painter can get acquainted with his subject in the course of several sittings, but usually the photographer does not have this advantage. You can get to know an artist or an author to a certain extent from his pictures or books before meeting him in the flesh, and I always tried to acquire as much of this previous information as possible before venturing in quest of great men, in order to gain an idea of the mind and character of the person I was to portray. I make friends quickly and am interested in the mental alertness of the people I meet. I think I may say that in many cases I came to be on close terms with the celebrities I portrayed. To take satisfactory photographs of people it is necessary for me to like them, to admire them, or at least to be interested in them. It is rather curious and difficult to explain exactly, but if I take a dislike to my sitter it is sure to show in the resulting portrait. The camera naturally records the slightest change of expression and mood, and the impression that I make on my sitter is as important as the effect he has on me.

The first literary lion I captured was George Bernard Shaw, who had just

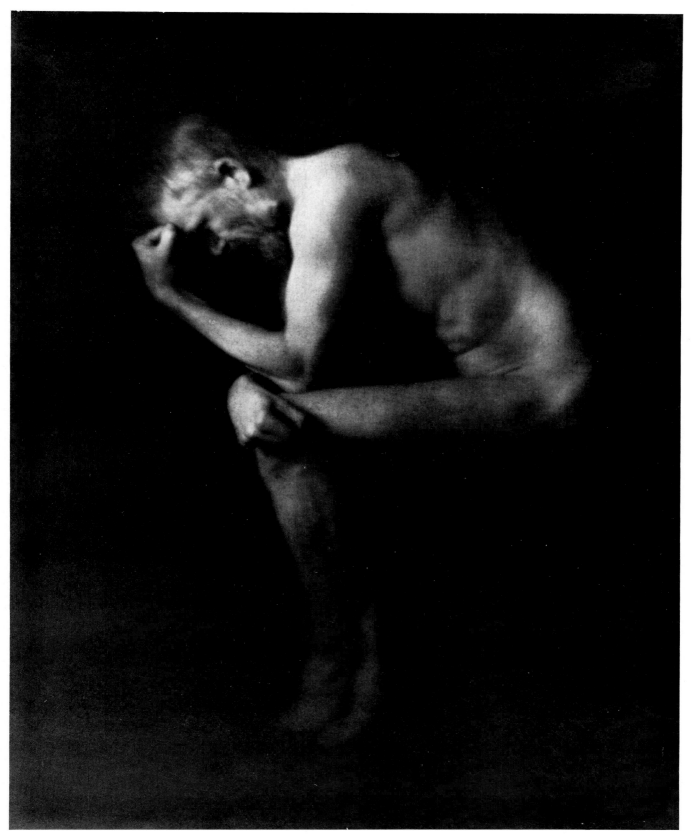

7. *Le Penseur* (Bernard Shaw). 1906

finished *Man and Superman*. I wrote to his London address, but he was at his new country home at Welwyn, and replied:

"26th July 1904. The Old House, 10 Adelphi Terrace, W.C.
 Harmer Green, Welwyn.

"Dear Sir,
 "Just now I am hard at work on a new play, and so do not want to come up to town if I can help it. But if you will come down here any day you choose to appoint (except Thursday next) by the 1.15 train from King's Cross, arriving at Welwyn station at 2.2, we will wait lunch for you; and you can photograph me afterwards to your heart's content. Bring Evans [Frederick H. Evans] with you if you can; I have not seen him for several months.
 "If it will save your carrying a lot of traps, I can place at your disposal some odds and ends of apparatus which are in a very incomplete condition, as I have only just moved into this house, and have not attempted to equip it completely for photography. But the bath room can be used as a makeshift dark room to change plates or develop a trial exposure. I have a 10″ × 8″ camera that will stretch to 30″ and a half-plate camera that will stretch nearly to 20″. I have an anastigmat (Dallmeyer's Stigmatic F6) that will cover a half-plate, and a Dallmeyer portrait lens F4, that will cover the side of a house with a telephoto attachment, and a half-plate without it. I have a quarter-plate hand camera, also available for telephoto work. Unluckily my 10″ × 8″ slides have no carriers for smaller plates, though I have ordered some. I have a few 10″ × 8″ Cristoid Orthochromatic films which are fresh, and a box of half-plate extra-rapid Ortho plates which I got 6 months ago, and some quarter and half plate Kodoids of uncertain age. But if you will tell me what you require, I will order them. The rooms here are whitewashed and fairly lighted; but I have not yet found out what exposure they will respond to.
 "Let me know as soon as you can what day will suit you, and whether Evans will come. Also what plates or films you would like to have, or what I can do to facilitate your operations.
 Yours faithfully,
 G. Bernard Shaw."

From this it will be seen that G.B.S. was not a button-pressing amateur as almost everyone else, but a serious photographer using a big plate camera with a tripod and ground-glass, and a Dallmeyer lens that covered the side of a house! Shaw was an enthusiastic photographer from 1898 until the end of his life. One of his last publications, when he was ninety-four, was a *Rhyming Picture Guide to Ayot St. Lawrence* (1950), a guide-book to his local place of residence, illustrated with his own photographs.

Shaw had seen some of my pictures reproduced in an American publication, and we had a mutual acquaintance in Frederick H. Evans, so that I was not entirely unknown to him, but his friendly courtesy to a comparative stranger was a typical example of his generous nature.

As I felt more confidence in using my own apparatus I refused Shaw's kind offer to lend me his, for who would trust to strange unknown cameras for such an important sitter?

Unfamiliar with English customs, I chose August Bank Holiday for my journey, not realizing that there would be no available conveyances, apart from the train. On arrival at Welwyn station I recognized Shaw on the platform from descriptions: a very tall man with red hair and beard, wearing a knitted Jaeger suit. He was carrying a long pole on which he proceeded to sling my heavy camera-case, and each taking hold of one end we brought it to his house. Shaw was a perfect model, and I made at least fifty photographs of him at one time or another (Plate 1). The friendship

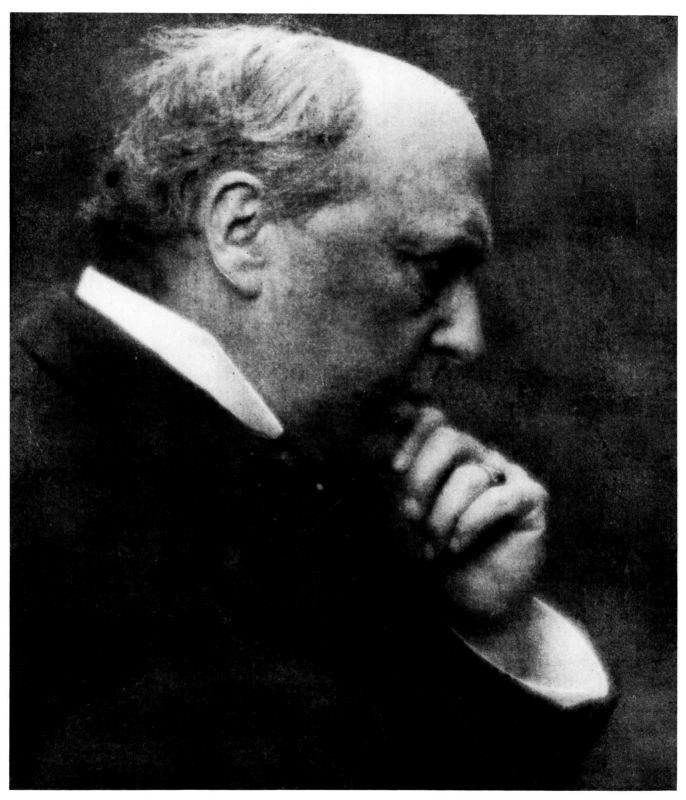

8. Henry James. 1906

which began on 1st August 1904 lasted throughout the years and was one of the pleasantest factors of my life in London.

Shaw is often depicted as a harsh critic, eager to demolish his victims, but this is completely unjust. He was the most kindly of men, any criticism being always tempered by an engaging smile, and he never in any circumstances lost his temper. Children and animals loved him, and they are not to be deceived where a kind heart is in question.

A few days after this visit to Shaw I photographed G. K. Chesterton (Plate 2). As usual in August in those days everyone of account was out of town. The weather was hot and sultry, and the fine rich green of the English countryside was very refreshing. Chesterton was staying at Westerham in Kent, and in reply to my letter said that if I would let him know which train I would come by he would meet me at the station. But on my arrival I found the platform deserted except for the book-stall attendant, who was dozing. As far as I can remember I was the only person to alight from the train. I strolled through the station and out into the road, but still no sign of the object of my quest. A dusty road stretched away into the distance, and as I had no idea of the direction in which to proceed I sat down on my large camera-case in the shade of the station and waited. Presently I perceived a cloud of dust in the distance, and as it approached out of it emerged, like the genie in the *Arabian Nights*, an enormous man in a green knickerbocker-suit who could be none other than the great G.K.C. himself. Chesterton was so large that he was said to offer his seat to *two* ladies in a bus, and when he and his wife shared a taxi he occupied the whole of the back seat while she, who was very thin, took one of the little tip-up seats in the front!

As Chesterton's house was far away on the top of a distant hill, and my camera was heavy, he proposed that we should adjourn to a nearby field, which we forthwith did, and under a tree I photographed him while he wrote an article on cabbages for the *Daily News*. Chesterton had a theory that a man should be able to open a dictionary at random and write an essay on the first word his eye chanced upon. He said once of Shaw that the only time he knew him to be more eloquent than when he was talking on a subject with which he was perfectly familiar, was when he was talking on a subject he knew nothing about! The same might perhaps be said of Chesterton himself, for I doubt whether he knew very much about cabbage culture, yet the article was so interesting that I, who carried it back to London and delivered it to the *Daily News*, and as a reward was permitted to read it, forgot to get out of the train when it came to its final stop at Charing Cross. The essay was written, I remember, on the backs of vivid yellow excursion announcements that we found in the station, and with my fountain pen. It is thus that literary masterpieces are created!

I have another very happy souvenir of Chesterton besides this photograph. It is a little privately printed book on London, illustrated by me and containing an essay by Chesterton. It is a charmingly amusing piece about a journey on the Inner Circle

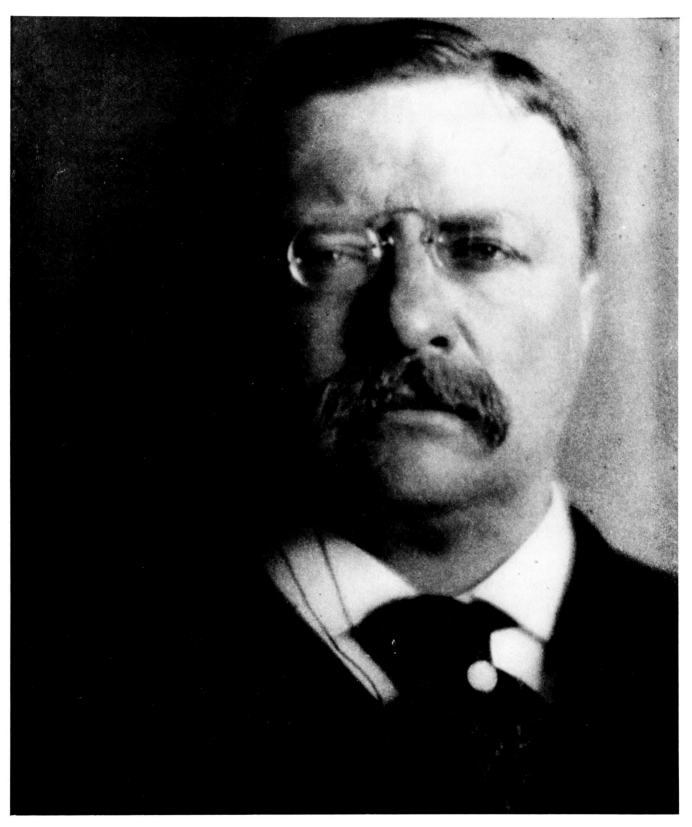

9. Theodore Roosevelt. 1907

of the London Underground Railway, and an old lady from the country who went around it all day because she always attempted to get out backwards and in every instance was pushed in again by the would-be helpful guard. The book is illustrated with photographs of the places corresponding to the names of the various Underground stations such as the Mansion House, the Tower, Blackfriars, the Temple and Westminster Bridge.

A couple of months after photographing Chesterton I visited George Meredith at his ivy-clad house on the slopes of Box Hill in Surrey. I had been told that he disliked being photographed, but I so greatly admired his books that I was drawn to make the attempt to record him. On a fine October day I made a pilgrimage to Dorking unannounced, and was immediately shown into the great man's presence, as he was expecting another visitor for whom I was happily mistaken! A model of perfect courtesy, Meredith never let me know at the time that an error had been made in my favour, but looked through the photographs I showed him with obvious interest, even enthusiasm. He remained firm, however, in his determination not to give me a sitting, explaining that he did not want to be photographed at the age of seventy-six and made to look like an old monkey as Tennyson did! In fact, he resembled a Greek bust, a head of Zeus, calm in its tranquillity, regal in its dignity.

With a certain bashfulness, for I was a diffident young man, I expressed my great admiration for *The Ordeal of Richard Feverel*, and asked how he had been able to capture the perfect idyll of young love which this early masterpiece of his reveals. Meredith smiled and said that the romance of youth was ever pure and wonderful to behold, and that to see it we had only to look back to our own first introduction to love to find the pattern. I was young enough, and near enough to this experience to understand exactly what he meant, and he himself not so old that he had forgotten it, though the book had been published forty-five years earlier.

I had too much respect for Meredith to press him for a sitting, but noticed his special interest in a photograph of a young mother and child, which caused his eyes to light up in a wonderful way, and he exclaimed in his mellow yet resonant voice: "How beautiful!" Next day I posted this picture to him and was rewarded with a letter in his own hand:

"You heap live coals on my head. I must be grateful, but your beautiful and undeserved present distresses me the more on account of the disappointment caused to you. It would relieve me in some degree if I could be by chance of any service to you. Supposing that your poetically artistic work is not yet known on this side of the water, an introduction to an editor of illustrated journals might help, or you might photograph my daughter—who is unlike me in always being ready to submit a pleasing countenance to the practitioner. She lives hard by me, near Leatherhead; and as she is pretty well known a good likeness of her would be useful.

"Accept my thanks and believe me,
Very truly yours,
George Meredith."

A week or so later a telegram arrived: "Come Monday 11.02 from Waterloo

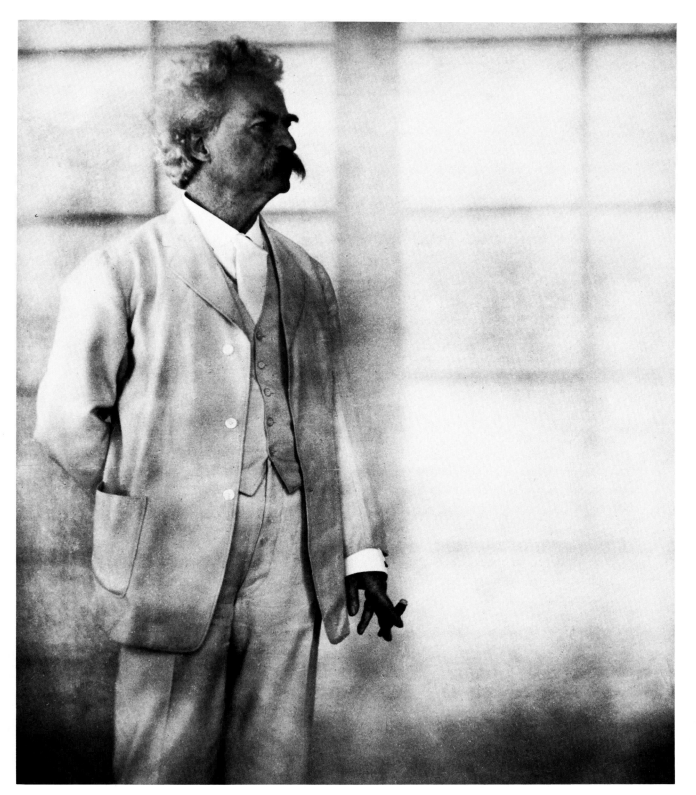

10. Mark Twain. 1908

South Station to Leatherhead. Carriage will meet you. Meredith."—"Carriage will meet you". How this determines the period, and how long ago it was—over sixty years.

Luckily it was again a fine day. George Meredith under the kind but firm direction of his daughter was in a submissive mood and I was able to take as many groups as I wished, and several close-ups of the grand old man himself (Plate 3). Meredith's favourite was a profile, which was used as the frontispiece of the first volume of the memorial edition of his works, published in twenty-seven volumes in 1910. It has an indrawn serenity worthy of the author of so many literary masterpieces.

After a journey to New York, next in the chronological order of my portraits of literary men comes H. G. Wells, already famous for his science-fiction *The Time Machine* (1895) and *The War of the Worlds* (1898). As in so many other cases the opportunity was created for me by G.B.S.

<div style="text-align: right">10 Adelphi Terrace, W.C.
1st Nov. 1905</div>

"Dear Coburn,

"I have just had a letter from Mrs. Wells to say that H.G.W. is in London and coming down to Folkestone by the 9 train tomorrow morning. Now the 9 train is knocked off; so he will either take the 8.30 (slow and cheap) or the 10 (boat train—swift and expensive). I am not sure of his address; but I am sending a note to the hotel he stayed at last time to tell him that we are going by the 10. So perhaps he will be with us.

"By the way, as this is my expedition, I shall claim you as my guest until I hand you over to Mrs. Wells.

<div style="text-align: center">Yours ever,
G. Bernard Shaw."</div>

In fact Wells was on the boat-train but we did not see him until we got out at Folkestone. It was raining slightly and we took a "four-wheeler" cab—this was before the day of taxis—to the house which Wells had just built on the sea-front at Sandgate. After luncheon I photographed him, and then in the dusk we three went for a walk. I remember how proud I was to have the opportunity of knowing two of the keenest minds in Britain, and how I listened with all my ears to their conversation without taking much part in it myself. Still very shy and awkward, I managed to spill a cup of tea in my lap and had to put on a pair of Wells's trousers while my own were being dried! Next day Shaw and I returned to London. I photographed Wells again on several other occasions. The portrait here reproduced (Plate 14) taken in 1909 after I knew him much better, has never been published before. Wells was always very kind to me. He wrote a charming foreword to my book on New York (1910) and hung a group of these pictures in his dining-room. He also encouraged me to illustrate *The Door in the Wall* and nine other of his short stories, allowing me to choose those I thought most suitable for photographic illustration. They were published in 1911 by Mitchell Kennerley of New York. At one of our meetings Wells presented me with a copy of *First and Last Things* in which he had drawn himself at his desk and me with a camera (Fig. 2) with the inscription: "Our business is to see what we can and render it."

<div style="text-align: center">32</div>

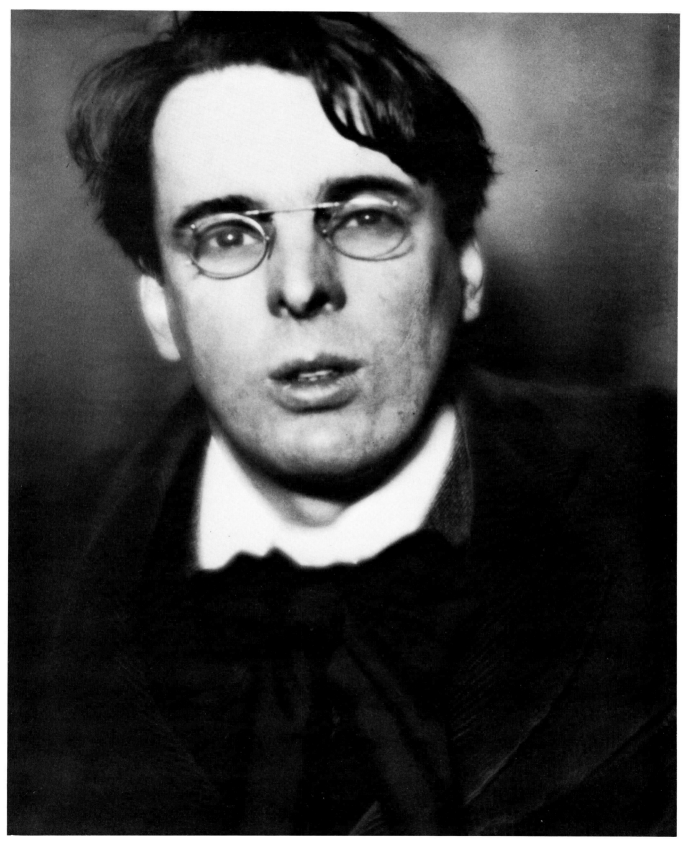

11. William Butler Yeats. 1908

Before photographing authors it was my custom to saturate myself in their writings, and this I did in the case of Edward Carpenter. I have, I believe, a complete collection of his books. I was an admirer of *Towards Democracy* for a number of years before I felt sufficiently acquainted with his writings to ask Edward Carpenter to sit to me. Then I heard him lecture, and that same evening I wrote telling him of my great desire to bring my camera to him. He replied that where he lived near Sheffield was six miles from the railway station, and that it would be impossible for me to come up, make his photograph, and return to London the same day, but that he expected to come to town the following week and would then come to me for the portrait. Accordingly late in November 1905 he came to see me at my rooms in Guildford Street, Bloomsbury, where I always lived and worked during my London visits between 1899 and 1909. I like to think that my portrait of Edward Carpenter (Plate 4) breathes the spirit of his remarkable book *Towards Democracy*, which I have read many times. It is the eyes which have the most to say in a portrait; they are "the windows of the soul", and particularly expressive in this photograph. The book of Carpenter's, however, which had the most influence upon me at the time of our meeting was *The Art of Creation*. I do not know what I would think of it if I were to re-read it now. The time at which a book is read is, of course, very important, for we are receptive to certain influences at certain phases of our mind's development, but it certainly made a deep impression upon me in 1905.

Nearly a year later, being in his part of the world accompanied by my mother, I wrote to Carpenter and received a cordial invitation to come out and see him at Millthorpe, Holmesfield. We took a local train from Sheffield, and then with difficulty got a carriage to take us the six miles of our journey. Black clouds came up and then we were in the midst of a downpour, and after what seemed an endless time we stopped at a little farmhouse. It was now quite dark, and the light in the window was very welcome, and still more Edward Carpenter's greeting and the warm fireside. Supper was spread, and the cab-driver was invited to share the meal in true Socialist style, and he turned out to be quite an interesting person. After supper Carpenter sat at the piano and improvised the most exquisite music, as mystic and full of dreams as his poetry. As a memento of the visit he inscribed a copy of *Days with Walt Whitman* and gave it to me. This completed a memorable evening. Some events have a way of indelibly impressing the memory, and this was such a one.

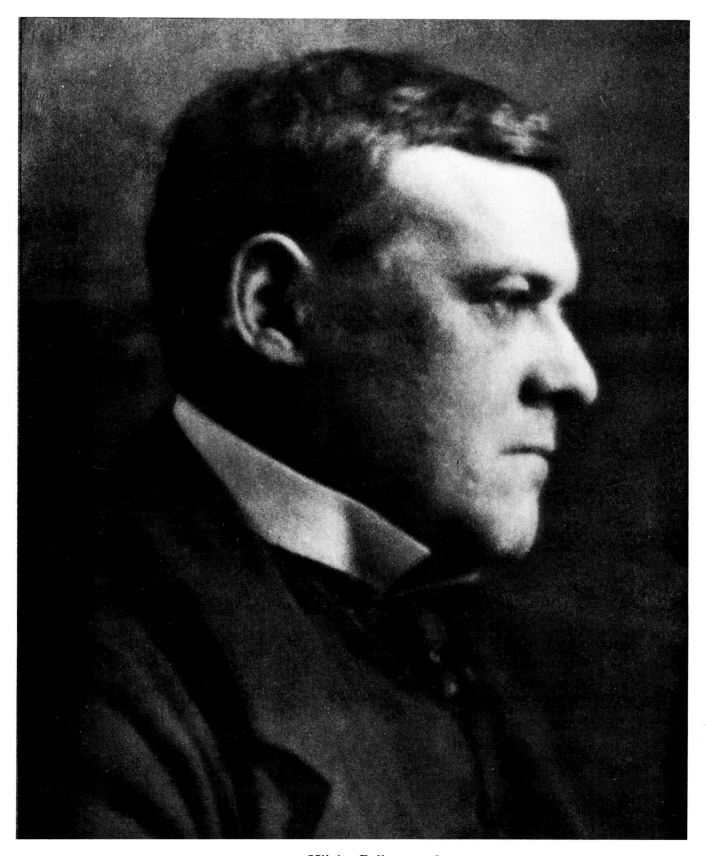

12. Hilaire Belloc. 1908

III. George Bernard Shaw

WHEN AT THE BEGINNING OF 1906 I was invited to give a one-man show at the Royal Photographic Society, G.B.S. remarked: "You will need someone to beat the big drum for you" and offered to write a preface to the catalogue. I still have the original manuscript typed by Shaw himself, with numerous pen corrections. It contains his oft-quoted simile: "The photographer is like the cod, which produces a million eggs in order that one may reach maturity." Questioned in 1949 about this remark by Helmut Gernsheim, Shaw admitted that it was based on personal experience!

Nothing could have been more valuable in bringing me recognition at the beginning of my photographic career, than the praise of the controversial dramatist and critic, whose fame was by now established.

"Mr. Alvin Langdon Coburn is one of the most accomplished and sensitive artist-photographers now living. . . . Mr. Coburn can handle you as Bellini handled everybody; as Hals handled everybody; as Gainsborough handled everybody; or as Holbein handled everybody, according to his vision of you. He is free of that clumsy tool—the human hand—which will always go its own single way and no other. And he takes full advantage of his freedom instead of contenting himself, like most photographers, with a formula that becomes almost as tiresome and mechanical as manual work with a brush or crayon.

"In landscape he shows the same power. He is not seduced by the picturesque, which is pretty cheap in photography and very tempting; he drives at the poetic, and invariably seizes something that plunges you into a mood . . . his impulse is always to convey a mood and not to impart local information, or to supply pretty views and striking sunsets. This is done without any impoverishment or artification: you are never worried with that infuriating academicism which already barnacles photography so thickly—selection of planes of sharpness, conventions of composition, suppression of detail, and so on. Mr. Coburn goes straight over all that to his mark, and does not make difficulties until he meets them, being, like most joyous souls, in no hurry to bid the devil good morning. And so, good luck to him, and to all artists of his stamp."

Referring earlier in his preface, to my complicated technique of imposing a gum-print on a platinotype, Shaw joked:

"If he were examined by the City and Guilds Institute, and based his answers on his own practice, he would probably be removed from the class-room to a lunatic asylum. It is his results that place him 'hors concours'. But, after all, the decisive quality in a photographer is the faculty of seeing certain things and being tempted by them. Any man who makes photography the business of his life can acquire technique enough to do anything he really wants to do: where there's a will there's a way. It is Mr. Coburn's vision and susceptibility that make him interesting, and make his fingers clever. Look at his portrait of Mr. Gilbert Chesterton [Plate 2] for example! 'Call that technique? Why, the head is not even on the plate. The delineation is so blunt that the lens must have been the bottom knocked out of a tumbler; and the exposure was too long for a vigorous image.' All this is quite true; but just look at Mr. Chesterton himself! . . . a large, abounding, gigantically cherubic person who is not only large in body and mind beyond all decency, but seems to be growing larger as you look at him—'swellin' wisibly' as Tony Weller puts it. Mr. Coburn has represented him as swelling off the plate* in the very act of being photo-

* As a matter of fact I took the portrait on "Cristoid" film, composed of two thicknesses of gelatine with no celluloid backing, so that on development a 10″ × 8″ negative expands to 12″ × 10″ size!

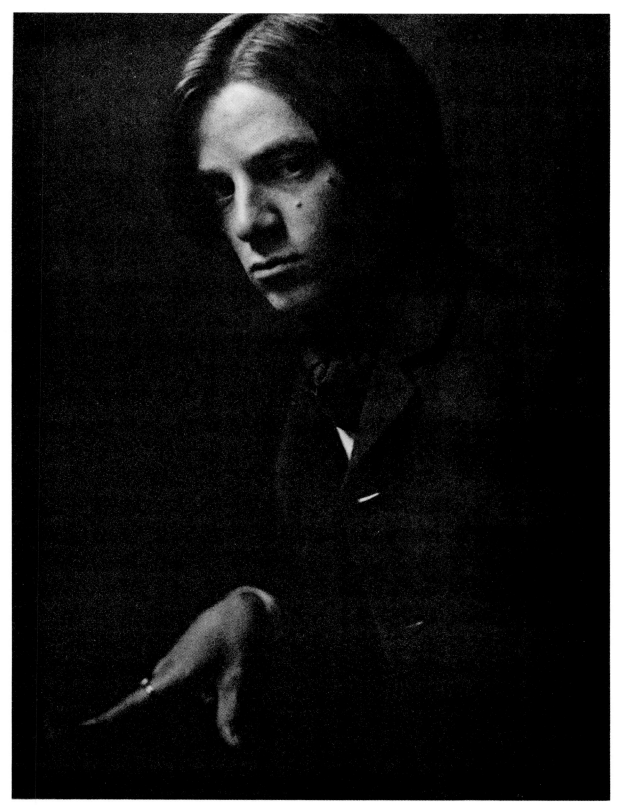

13. Self-portrait of Alvin Langdon Coburn. 1905

graphed, and blurring his own outlines in the process. Also, he has caught the Chestertonian resemblance to Balzac, and unconsciously handled his subject as Rodin handled Balzac. You may call the placing of the head on the plate wrong, the focussing wrong, the exposure wrong, if you like; but Chesterton is right; and a right impression of Chesterton is what Mr. Coburn was driving at."

My exhibition, which was on for seven weeks, opened on 5th February. A week later Shaw wrote from Welwyn:

"I find that I cannot afford to lose my morning's work on Wednesday, as I am at high pressure. Besides, my wife wants to see your show. So we shall not come up until the afternoon. Expect us somewhere about two o'clock.

"If you would care to add A. B. Walkley, the *Times* dramatic critic, to your collection of portraits, you will find him an admirer. His address is 36 Tavistock Square, W.C., and if you offer him a sitting he will jump at it.

G. Bernard Shaw."

It was around this time that I decided to acquire a silk hat with a wide brim simply because James McNeil Whistler used to wear one and I was a great admirer of his! Accordingly I went to Heath's, the fashionable hatters, and ordered one to to be made. When it was ready I went to try it on, and as I was going to a private view of a photographic exhibition that afternoon I told the shop assistant that he could send the old hat home and I would wear the new one. "In the street, sir?" he gasped in astonishment. I really believe he thought that the hat was intended for a period play! However, I proceeded happily down Oxford Street in this wonderful creation (Plate 5) which I wore for a number of years on formal occasions of this kind. In those days I was indifferent as to what people said about my appearance, or perhaps it would be more truthful to admit that I really enjoyed being noticed! How pleasant it is to be young!

On 11th April 1906 G.B.S. wrote:

"Dear Coburn,

"I leave town this afternoon and shall not return until Saturday, when I shall be rehearsing hard all day. On Sunday I go to Paris and shall stay there for the rest of the month, probably, sitting to Rodin.

"This seems to cut me out of meeting George Ade; but if you have him sufficiently close at hand to bring him here this afternoon at four, I shall be on view until half past.

"Send me word by messenger whether I may expect you or not. I enclose writing material to save trouble.

Yours ever,
G. Bernard Shaw."

I did take the American humorist to see Shaw that afternoon, and told him of my ambition to photograph the great sculptor. Soon afterwards, when the series of sittings was in progress, G.B.S. sent me a postcard:

Palais d'Orsay,
Grand Hotel de la Gare du Quai d'Orsay,
Paris.
17th April 1906

"Come along any time you like. Rodin, seeing that I had a camera, invited me to photograph his place if I liked. I took the opportunity to press your claims; and he said certainly. I guaranteed you a good workman. The sculpting sittings are at Meudon 25 minutes train from Paris, where he has a lot

38

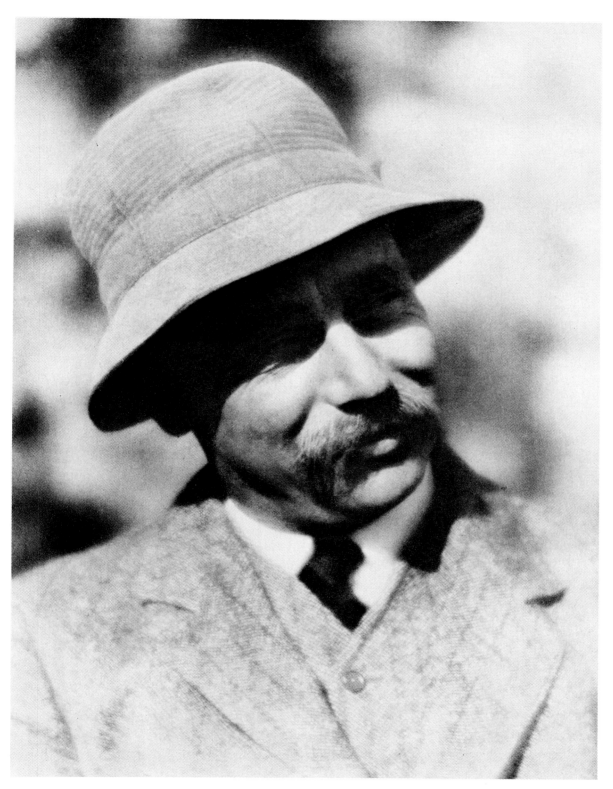

14. Herbert George Wells. 1909

of beautiful things. No photograph yet taken has touched him: Steichen was right to give him up and silhouette him. He is by a million chalks the biggest man you ever saw; all your other sitters are only fit to make gelatine to emulsify for his negative.

<div align="right">G.B.S."</div>

Naturally I was overjoyed and lost no time in making the journey to Paris where I stayed at the same hotel as Mr. and Mrs. Shaw. On introduction to the celebrated sculptor I felt very shy about my sketchy French, but Shaw encouraged me: "Plunge in, Coburn, your French cannot be worse than mine!" I made a number of photographs including one of Shaw and Rodin with the clay model of the bust between them in process of creation—a really historic picture. I was also permitted to make a number of negatives of Rodin's most beautiful sculptures, and of some antiques. My greatest pleasure, however, was to make portraits of the sculptor himself, which amply repaid me for my Channel crossing. He looked like an ancient patriarch or prophet, with his flowing beard and black skull-cap (Plate 6).

On 21st April I accompanied Mr. and Mrs. Shaw to the unveiling ceremony of Rodin's sculpture "Le Penseur" outside the Panthéon.* The next morning G.B.S. surprised me by suggesting that after his bath I should photograph him nude in the pose of "Le Penseur". I had photographed him in almost every conceivable way, he said, so now I might as well complete the series as "The Thinker"—his true role in life. As for nudity, G.B.S. said to Frank Harris "though we have hundreds of photographs of Dickens and Wagner, we see nothing of them except their suits of clothes with their heads sticking out; and what is the use of that?" I think G.B.S. was quite proud of his figure, and well he may have been, as the photograph testifies (Plate 7). When exhibited under the title "Le Penseur" at the London Salon of Photography it aroused considerable comment in the press. Reporters asked me if it were really a photograph of Shaw, and they asked him the same question, but I referred them to him for verification and he referred them to me, so they remained mystified. During his lifetime the photograph was never published, although G.B.S. had no objection to this, saying I could do what I liked with it.

The day after I returned to London Shaw wrote:

<div align="right">24th April 1906</div>

"The first thing Rodin asked today was whether you had photographed the antiques. Later on he told Charlotte that he wished you had taken a group of us all instead of taking dozens of pictures of himself; but I think this apparent ingratitude was really only gallantry. He further remarked that photographers took so long to produce their results—instead of knocking them off in 12 days like a bust— that one lost interest in the sitting. He supposed you would be months and months before you sent him anything.

"For your next visit tintypes are clearly indicated.

"The antiques appear to be what he is most anxious about. I should feed him with the results two or three at a time to keep up the excitement.

<div align="right">G.B.S."</div>

* This bronze statue has since been transferred to the grounds of the Musée Rodin, 77 rue de Varenne, St. Germain, Paris.

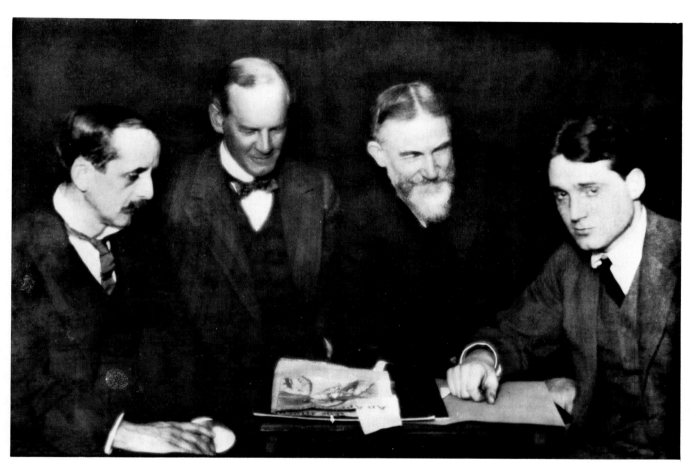

15. "The Dramatists" : (Sir) James Barrie, John Galsworthy,
George Bernard Shaw, Harley Granville-Barker. 1909

Tintypes were cheap direct positives on sheet-metal, produced in a few minutes by street and beach photographers. I wonder what Shaw and Rodin would have thought of the modern Polaroid camera in which the picture is automatically finished in ten seconds!

Rodin paid two visits to England to perfect the bust. Mrs. Shaw, writing to the sculptor after the arrival of the bronze, said it was such a striking resemblance of her husband that sometimes it frightened her.

G.B.S. informed me on 7th October 1906:

"I told Mrs. Patrick Campbell that you wanted to photograph great women as well as great men; and she would sit to you if you were a really good man as well as a gifted artist. If you care to follow this up, her address is 33 Kensington Square, W.

"If I could squeeze out the time I should write an article on the nudes at the Salon & R.P.S. for A.H.H.*

"I have no objection to anyone having a copy of Le P [Le Penseur] if they are willing to pay for it.
G.B.S."

* A. Horsley Hinton, editor of *The Amateur Photographer*.

Shaw gave me a letter of introduction to Mrs. Patrick Campbell in which, referring to my photograph of him as "Le Penseur" he suggested that I should photograph her in the same way: "Coburn has just photographed me 'in the altogether'." I did photograph the famous actress, but of course clothed.

Time and again Bernard Shaw helped me by arranging sittings with the great men of the time. In 1909 the well-known critic William Archer was writing an article for *McClure's Magazine* and wanted to illustrate it with a group of the dramatists J. M. Barrie, John Galsworthy, Bernard Shaw and Harley Granville-Barker. When I told Shaw of the insuperable difficulty of getting them all together, he flatly contradicted me: "Not at all: I will invite you all to lunch!" And so it came to pass at his London home at Adelphi Terrace. This was a couple of years after the seasons of repertory drama under the management of J. E. Vedrenne and H. Granville-Barker at the Court Theatre, London, where between 1904 and 1907 so many of Shaw's plays were produced, and he was closely in touch with all these dramatists. It was an amazing lunch with brilliant conversation, as one would expect, and Shaw's sparkling wit was very much in evidence. He called my picture (Plate 15) "Dissecting a Play", saying it reminded him of Rembrandt's painting of four surgeons engaged in a dissection. In fact "The Anatomy Lesson of Dr. Tulp" (1632) shows one surgeon demonstrating to seven members of the Guild of Surgeons, Amsterdam.

16. Alfred Stieglitz. 1912

IV. Landscapes and Cityscapes

IT MUST NOT BE ASSUMED that my pursuit of celebrities caused me to neglect landscape work. My one-man show at the Royal Photographic Society—and subsequently at the Liverpool Amateur Photographic Association—included, in addition to twenty-eight portraits mostly of celebrities, thirty-six views taken in London, Liverpool, Edinburgh, Rome, Venice and elsewhere. It was during the time that I was showing my exhibition in Liverpool that I took the picture entitled "Spider Webs" (Plate 37). There were still some sailing ships in the Liverpool docks, and their beautiful figureheads were to be seen reaching out over the edge of the quays.

My aim in landscape photography, as Bernard Shaw wrote, "is always to convey a mood and not to impart local information." This is not an easy matter, for the camera if left to its own devices will simply impart local information to the exclusion of everything else.

If you ask how can a camera be made to convey a mood, I can only say that photography demands great patience: waiting for the right hour, the right moment, and recognising it when you see it. It also means a training in self-control, which teaches you to forgo the subjects, attractive in some respects, which you know are not entirely satisfactory. The artist-photographer must be constantly on the alert for the perfect moment, when a fragment of the jumble of nature is isolated by the conditions of light or atmosphere, until every detail is just right. I always think in this connection of Whistler's classic remark that "nature was creeping up a bit". The astonishing thing about it is that nature will "creep up a bit" if you sit patiently and wait for her in ambush. If she knows you are there she is off in an instant like a frightened doe.

To speak of composition in connection with photography seems, on first thinking of the problem, to be rather a contradiction in terms—that you really ought to say "isolation", which would perhaps come nearer to what is done in most cases; but whilst it is impossible to re-arrange trees and hills in the manner of the painter, it *is* possible to move the camera in such a way that a completely new arrangement is achieved, a few inches sometimes changing the entire design. For the creation of a picture, vision is of prime importance, and patience, discrimination, and even marksmanship are decisive factors.

Sunshine and water form, I believe, the landscape photographer's finest subject matter. Is there a more perfect way of studying and permanently recording the subtle play of sunlight on moving water than photography? I have spent hours on the

44

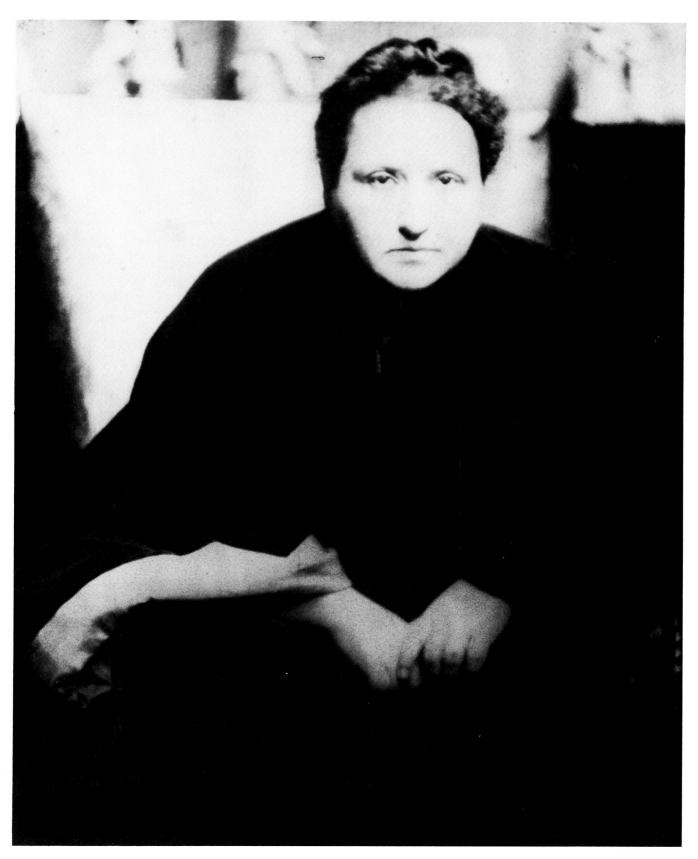

17. Gertrude Stein. 1913

canals of Venice (Plate 35) and on the waterways of many other places (Plate 33) feasting my eyes on the rhythmic beauty and the poetry of liquid surfaces, hours punctuated at intervals of exceptional charm by the click of my shutter. They have been rare days, and full of great joy—for whatever the camera may not do, it certainly does this one thing: it teaches you to look at the world around you, and at last, if you persevere, you will be rewarded with the satisfaction of self-expression.

Clouds are especially good subject matter for the photographer. The versatility of the Great Creator of Clouds is almost unbelievable and yet the fact is ever before us to excite our wonder. The patterns of moving clouds and water are never the same from now to all eternity, and these patterns are ever moving to our continual delight. I have made hundreds of photographs of clouds and never tire of them. Once I made a little book illustrating Shelley's Ode "The Cloud" with six original platinum prints. Only sixty copies were to be printed and even all these were not made. I only know of one other surviving copy in addition to my own, so this is doubtless my rarest book!

That photography is able to render sunshine is one of its especial charms. An effect of sunshine is a thing that you cannot command any more than you can produce by magic a certain kind of weather. The photographer is, to this extent, dependent upon nature for his results, but he must be continually alert, otherwise he will miss some rare treasure, some manifestation of loveliness, which if he had been indifferent or unobservant would have escaped him. The search for a picture is almost as enjoyable as its final capture, and its success often involves an infinite capacity for taking pains. There is a pleasant story of a man who travelled around the world searching for perfect loveliness and returned home to find it upon his own doorstep! Beauty is always there to be found by the trained eye, even in the simplest things. One of the values of photography is the training it gives in the discovery of what constitutes a picture.

These are the days of miniature cameras with little view-finders of almost microscopic dimensions, but I find them very difficult to use. I like to compose my pictures to the edge, and to know exactly what I shall get. I am not at all sure that elaborate and expensive modern miniature cameras contribute anything to the type of picture I like to take, which are usually of fairly static subjects. To say "You must have a wonderful lens!" intending to be complimentary, is equivalent to praising a painter for the quality of his brushes. Photography is, or can be, an art, and artists are born and not made by their lenses or brushes. There is no formula for success in photography any more than there is for anything else in the world which is really worth while.

The inexperienced photographer may find it useful to carry about some kind of "finder", even if it is only a simple frame to isolate the subject of the possible picture. Later, as he gains experience, this will become unnecessary, for eye-training comes with use.

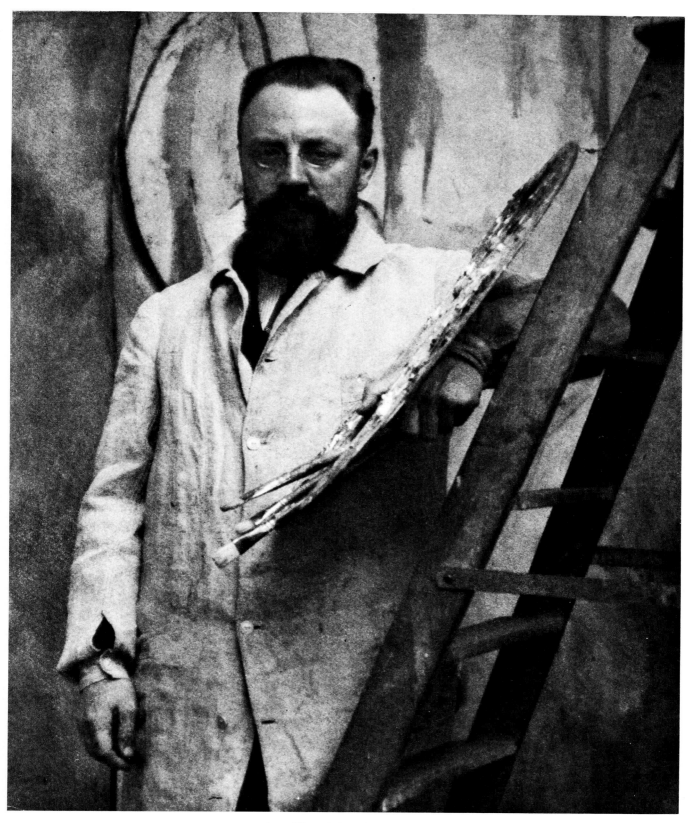

18. Henri Matisse. 1913

There are countless interesting things in the world waiting to be recognized and captured, and the photographer has unique opportunities for recording for posterity aspects of the world around him, in subtle gradations of light and form not possible in any other medium. Photography helps us not only to remember, but to see afresh, and to cultivate the capacity to see with more clarity, and this is of great value in the ability to lead a fuller and richer life.

I have sometimes been asked which I prefer—my portraits of people or my portraits of places. My answer has always been that when I am making portraits of people I prefer these, but when I am engaged in the portrayal of places, they become the centre of my eager interest. Probably landscapes and "cityscapes" offer more scope for design and pattern than do portraits. And of course there are the Vortographs (Plates 54, 55) which are to me perhaps the most interesting of all.

I am particularly fond of unusual vistas of cities and have spent much of my life endeavouring to discover them, as I believe my books on London, New York and Edinburgh will testify; and I have in mind also books on Paris, Boston and other cities which I may one day add to those I have already published.

Living on and off in London for nearly thirty years, I loved to photograph the great city (Plates 33, 34, 40). On my second stay, in 1904, I wrote enthusiastically to Alfred Stieglitz: "After all, there is no place like London. I have never really done any photographic work before—wait until you see the new stuff!"

I consider Edinburgh one of the most beautiful cities in the world, and Robert Louis Stevenson appreciated it as few have done. For over fifty years I have followed lovingly in his footsteps, endeavouring to see it as I thought he saw it, and I hope that he would have approved of what I have done in illustrating his *Edinburgh Picturesque Notes*.

Edinburgh is the land of the toy theatre of Stevenson's childhood and mine. A penny plain and twopence coloured. I have seen the actual shop where he rubbed his youthful nose against the window, and I am sure that it was "twopence coloured" that he chose if this then large sum was available to him at the time! All the world is "twopence coloured" to the discoverer of true romance, and of all men Stevenson was most surely able to introduce us to this land he made his own. I never met Stevenson in the flesh. It is one of my great regrets that I came just a little too late to make his portrait, but I have all his books and have read them many times, so that I seem to know him better than some of my other friends. Through his Edinburgh and in his Edinburgh I seem to know him best of all.

Greyfriars Churchyard is the heart and centre of Stevenson's Old Town, and in the chapter of my book in which he commemorates this memorable place there are no fewer than five illustrations of which this "Tree in Greyfriars" (Plate 36) is perhaps the most characteristic. This vision of a mouldering churchyard full of tombs is not in the least gloomy or depressing. It has a kind of charm, a serene beauty of its own which lifts it out of the commonplace, and gives it stability and character

19. Frank Brangwyn. 1913

which some ancient localities seem to acquire with time and association, as difficult to explain as the mysteries of love and death and the great human emotions, but there to be discovered by the visionaries of future generations who follow in the footsteps of discerning Stevenson.

The photograph of the harbour of Cadiz (Plate 38) was made during a Mediterranean cruise in the summer of 1906. I rarely indulge in compositions which approach the square shape, but this seemed to call for such a frame, and variety has its own value. I like the filled pattern of this squarish picture, with its hanging ropes. I delight in anything Moorish as it brings with it a flavour of the *Arabian Nights* with all its glamour. Spain with its vivid sunshine and white-walled buildings has a certain kinship with the coasts of northern Africa, even with its ships with their picturesque sails; and was not Spain at one time invaded by the Moors, who conquered much of its southern parts, leaving behind them such glories as the Alhambra, and the wonders of Arabic mysticism, culture and art?

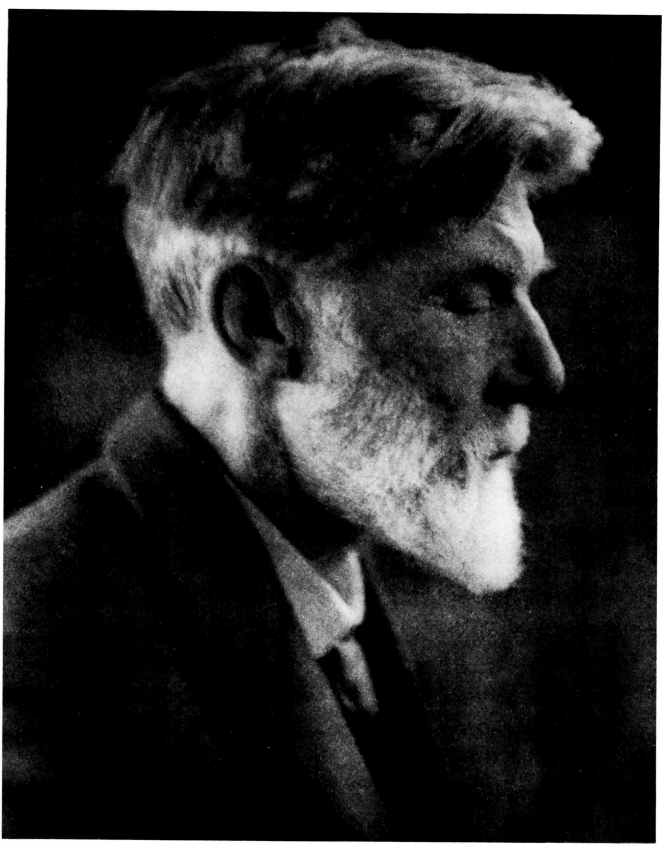

20. Robert Bridges. 1913

V. Illustrating Henry James

SOON AFTER RETURNING from this cruise I embarked upon one of the most interesting experiences of my photographic career, for it was my unique privilege in 1906-1907 to provide the frontispieces for each of the twenty-four volumes of the collected edition of Henry James's works.

There are some people you cannot help liking the moment you see them, and Henry James was, for me, such a person. My earliest portraits of him had been made for the *Century Magazine* in New York in April 1905, but the one here reproduced (Plate 8) was taken in June the following year at his beautiful old house in the ancient town of Rye, Sussex—one of the Cinque Ports. Henry James met me at the station, and I had a most enjoyable visit, and produced a portrait which evidently satisfied him, for he subsequently suggested that I should make photographs to be used in all the other volumes of the forthcoming collected edition: and thus began our friendship. His home, Lamb House, Rye, appeared as frontispiece to Volume 9, *The Awkward Age*, where it was entitled "Mr. Longdon's". During my second visit to Rye, to photograph the house, James presented me with a charming little two-volume edition of *The American* published in 1883, inscribed with my name and his and dated Lamb House, July 4th, 1906. It was really the third of July, and one can see that he started to make a figure three in the date and then changed his mind and, with a chuckle, made it a four instead, for the Fourth of July is American Independence Day and a very appropriate date to be inscribed in a copy of this book!

My first adventure in connection with the James frontispieces was a visit to Paris. I went there at the beginning of October 1906, armed with a detailed document from James explaining exactly what he wanted me to photograph.

He was especially keen to have a *porte cochère* or carriage entrance of one of the aristocratic mansions such as that described in *The American*. His knowledge of the streets of Paris was amazing. He enumerated nine or ten streets I was to traverse, thoroughly saturating my mind with the type of portal required. It was not to be as grand as that of the British Embassy, but I was to see this as being the kind of thing required, only in lesser degree. The letter continued: "Once you get the type into your head, you will easily recognise specimens by walking in the *old* residential and 'noble' parts of the city . . . Tell a cabman that you want to drive through every street in it, and having got the notion, go back and walk and stare at your ease." This is thoroughness, and shows H.J.'s way of approaching a problem. The result, entitled "The Faubourg St. Germain" (Plate 39) forms the frontispiece of *The*

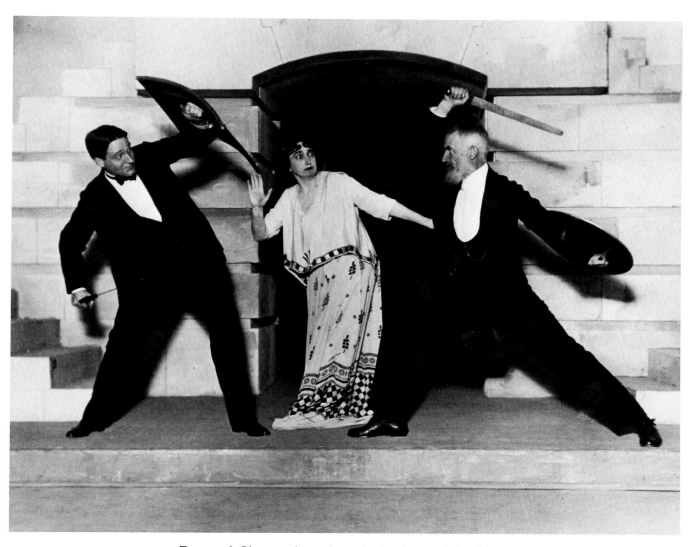

21. Bernard Shaw rehearsing *Androcles and the Lion.* 1913

American, which is the second volume of the collected edition.

With regard to the Place de la Concorde H.J. advised:

"Look out *there* for some combination of objects that won't be hackneyed and commonplace and panoramic; some fountain or statue or balustrade or vista or suggestion (of some damnable sort or other) that will serve in connection with *The Ambassadors,* perhaps; just as some view, rightly arrived at, of Notre-Dame would also serve—if sufficiently bedimmed and refined and glorified; especially as to its Side on the River and Back ditto."

Concerning the seventh volume he wrote:

"I yearn for some aspect of the Théâtre-Français for possible use in *The Tragic Muse*; but something of course of the same transfigured nature; some ingeniously hit-upon angle or presentment of its rather majestic big square mass and classic colonnade."

In all I made six illustrations during this Paris visit: "The Court of the Hotel" for *The Reverberator*; "By Notre-Dame" for the first volume of *The Ambassadors*; and lastly "The Luxembourg Gardens" for the second volume of the same tale. The instructions for this photograph were:

"There is another passage in the same book [*The Ambassadors*] about the hero sitting *there* (in the Luxembourg Gardens) against the pedestal of some pleasant old garden-statue to read over certain letters with which the story is concerned. Go into the sad Luxembourg Gardens to look for my right garden-statue (composing with other interesting objects) against which my chair was tilted back. Do bring me something right, in short, from the Luxembourg."

The instructions ended with the kindly benediction "My blessing on your inspiration and your weather." I believe he was happy with the result.

Early in November Henry James came up to London and we gloated together over my prints. Though sixty-three years old, H.J. was like a boy, always displaying unquenchable and contagious enthusiasm over every detail concerning these illustrations. This made it a joy to work with him. That is the splendid thing about an artist, whether his medium of expression be pigments, or sounds, or words, or even the Art of life, he does not "grow up", grow stale, or lose freshness of outlook; and Henry James was a true artist in this respect. He never lost the capacity to see things with that freshness of vision, as they are beheld by the very young or the very wise.

My next lengthy pilgrimage in search of frontispieces was to Italy, which yielded four subjects, two in Rome and two in Venice. The Roman pictures were: "Roman Bridge" for the second volume of *Portrait of a Lady,* and "By St. Peter's" for *Daisy Miller.*

I arrived in Venice in the middle of December. Never before or since have I felt so miserably cold and damp, until I moved into a German pension with enormous stoves and old-fashioned feather beds.

As in the case of Paris, I was provided with most detailed instructions regarding my pictures. The two Venetian illustrations I was to produce were for *The Aspern Papers* and *The Wings of the Dove*—both novels that have in recent years been successfully dramatized.

"Juliana's Court" was the very place Henry James had in mind when writing

22. (Sir) Jacob Epstein. 1914

The Aspern Papers. The original Juliana, however, had lived in old age in Florence, where she died. She was Claire Claremont, mother of Byron's daughter Allegra, and the Aspern papers of the novel were in fact those of Shelley. The palace which Henry James had taken for his setting was the Palazzo Capello, Rio Marin, which was occupied by friends to whom he gave me a letter of introduction. He sent me lengthy directions how to find it.

"The extremely tortuous and complicated walk—taking Piazza San Marco as a starting point—will show you so much, so many bits and odds and ends, such a revel of Venetian picturesqueness, that I advise your doing it on foot as much as possible. . . . It is the old faded pink-faced, battered-looking and quite homely and plain (as things go in Venice) old Palazzino on the right of the small Canal, a little way along, as you enter it by the end of the Canal towards the Station. It has a garden behind it, and I think, though I am not sure, some bit of a garden wall beside it; it doesn't moreover bathe its steps, if I remember right, directly in the Canal, but has a small paved Riva or footway in front of it, and *then* water-steps down from this little quay. As to that, however, the time since I have seen it may muddle me; but I am almost sure. At any rate anyone about will identify for you Ca Capello, which is familiar for Casa C.; *casa*, for your ingenuous young mind, meaning House, being used, save for the greatest palaces, as much as palazzo. You must judge for yourself, face to face with the object, how much, on the spot, it seems to lend itself to a picture. I think it *must*, more or less, or sufficiently; with or without such adjuncts of the rest of the scene (from the bank opposite, from the bank near, or from wherever you can damnably manage it) as may seem to contribute or complete—to be needed, in short, for the interesting effect. . . . What figures most is the big old Sala, the large central hall of the principal floor of the house, to which they (my friends) will introduce you, and from which, from the larger, rather bare Venetian perspective of which, and preferably looking towards the garden-end, I very much hope some result. In one way or another, in fine, it seems to me it ought to give something. If it doesn't, even with the help of more of the little canal-view etc., yield satisfaction, wander about until you find something that looks sufficiently like it, some old second-rate palace on a by-canal, with a Riva in front, and if any such takes you at all, do it at a venture, as a possibly better alternative. But get the Sala at Ca Capello, without fail, if it proves at all manageable or effective."

I was able to photograph Ca Capello in the way H. J. wished.

"For the other picture, that of *The Wings*, I had vaguely in mind the Palazzo Barbaro . . . the very old Gothic one . . . The Barbaro has its water-steps beside it, as it were; that is a little gallery running beside a small stretch of side-canal. But in addition it also has fine water-steps (I remember) to the front door of its lower apartment. (The side-steps I speak of belong to the apartment with the beautiful range of old *upper* Gothic windows, those attached to the part of the palace concerned in my story). But I don't propose you should attempt here anything but the outside; and you must judge best if you can take the object most effectively from the bridge itself, from the little campo in front of the Academy, from some other like spot further—that is further towards the Salute, or from a gondola (if your gondolier can keep it steady enough) out on the bosom of the Canal.

"If none of these positions yield you something you may feel to be effective, try some other palace. . . . And do any other odd and interesting bit you can, that may serve for a sort of symbolised and generalized Venice in case everything else fails; preferring the noble and fine aspect, however, to the merely shabby and familiar (as in the case of those views you already have)—yet especially *not* choosing the pompous and obvious things that one everywhere sees photos of."

Perhaps the most intimate and personal of all the questing for pictures was the search for and capture of the London scenes, for with most of these I had the personal guidance and collaboration of the author. Henry James knew his London as few men have known it, in all its quaintness, its mystery, and its charm. He obviously enjoyed our search, for he wrote of the street scenery of London "yielding a rich harvest of treasures from the moment I held up to it, in my fellow artist's company, the light of our fond idea—the idea, that is, of the aspect of things or

23. Augustus John. 1914

combinations of objects that might, by a latent virtue in it, speak of its connection with something in the book, and yet at the same time speak enough for its odd or interesting self." H.J. knew so perfectly what we should achieve, for after all it was *his* books we were illustrating, but in spite of this, the photographs were essentially mine!

The afternoon that we went to St. John's Wood to photograph the little gateway and house which was to serve as the illustration for the second volume of *The Tragic Muse* was an unforgettable experience. It was a lovely afternoon, I remember, and H.J. was in his most festive mood. I was carefree because this time I did not have to hunt for the subject, for I had the most perfect and dependable guide, the creator and author himself. I had not even read *The Tragic Muse*, but I shared his enthusiasm when after considerable searching we came upon exactly the right subject. Where the house is located I do not now recall, it may in fact no longer exist, for so much of London has passed away into the domain of forgotten things; but in the photograph it is preserved, crystallised as a memento of what Henry James had meant it to be.

Now it was tea-time, and pleasantly fatigued by our exertions, now triumphantly rewarded, we looked for a teashop to refresh ourselves, but were only able to find a baker's shop. We descended on this and came out with Bath buns, which we thankfully devoured as we walked down the street.

Although not literally a photographer, I believe Henry James must have had sensitive plates in his brain on which to record his impressions! He always knew exactly what he wanted, although many of the pictures were but images in his mind and imagination, and what we did was to browse diligently until we found such a subject. It was a great pleasure to collaborate in this way, and I number the days thus spent among my most precious recollections.

The reason why James decided on photographic illustrations for his novels and tales was because, as he put it, photographs were "in as different a 'medium' as possible." He further explained: "The proposed photographic studies were to seek the way, which they have happily found, I think, not to keep or to pretend to keep, anything like dramatic step with their suggested matter. This would have disqualified them to my rigour: but they were 'all right' in the so analytic modern critical phrase, through their discreetly disavowing emulation."

The triumphant culmination of this adventure, from my point of view, was the commemoration by the author himself in the preface to *The Golden Bowl* (the final volume in the series) of our search for and ultimate capture of these pictures. H.J. explains that the photographs were not to be competitive with the text, or obvious illustrations, but "images always confessing themselves mere optical symbols or echoes, expressions of no particular thing in the text, but only of the type or idea of this or that thing. They were to remain at the most small pictures of our 'set' stage with the actors left out."

24. Feodor Chaliapin. 1914

The only way to do full justice to Henry James's tribute to our vision of Portland Place is to quote his own words:

> "It was equally obvious that for the second volume of the same fiction (*The Golden Bowl*) nothing would so nobly serve as some generalized vision of Portland Place. Both our limit and the very extent of our occasion, however, lay in the fact that unlike wanton designers, we had not to 'create' but simply to recognize—recognize, that is, with the last fineness. The thing was to induce the vision of Portland Place to generalize itself. This is precisely, however, the fashion after which the prodigious city, as I have called it, does on occasion meet halfway those forms of intelligence of it that *it* recognizes. All of which means that at a given moment the great Philistine vista would itself perform a miracle, would become interesting for a splendid atmospheric hour, as only London knows how, and that our business would be to understand."

I learned much from my collaboration with this great author, and for this experience I am deeply grateful.

One of the last letters I received from Henry James (the forty-ninth, the last but one) written just before the first world war, spoke of failing health and heart trouble, but it was a brave and cheerful letter full of confidence that we should meet again. Alas! we never did. When Henry James died a year and a half later—a British subject, honoured with the Order of Merit, admired by the discriminating of many lands, and beloved by his friends—I have no shame in confessing that I wept. It has been said, wisely I think, that we live on in the memory of our friends. If this be so, I am happy in the thought that this truly great portrayer of the art of life lives on to some extent in my own memory, and that I may have been able to impart to others something of the enduring quality of his personal charm, and his never-failing courtesy and kindness.

25. Maurice Maeterlinck. 1915

VI. Other Portraits

A NUMBER OF OTHER outstanding compatriots of mine came before my lens. Early in 1907, during one of my many visits to the United States, when I took the last three illustrations for Henry James's collected works, I was privileged to photograph Theodore Roosevelt for an American magazine. Many of us are hero-worshippers, and to meet our heroes face to face does not always come up to our expectations, but in this instance I was not disappointed. Roosevelt was all that I had anticipated, and more.

The sitting had been arranged for nine o'clock in the morning, and arriving at the White House a quarter of an hour early, I had my camera set up in readiness. As the clock struck the hour President Roosevelt appeared, and I asked him how long he could give me. The answer was unexpected: "As long as you like!" Obviously this polite remark was not meant to be taken literally, but I managed to make five exposures in a quarter of an hour (Plate 9). Then the President shook hands with me and I never saw him again, but the memory remains of a very courteous but dynamic personality, who ruled the nation wisely and well. No doubt he shook tens of thousands of men by the hand, but only by virtue of my photography could *I* have claimed the undivided attention of my country's chief executive for a quarter of an hour.

I also photographed the next President, William Howard Taft, in 1910.

Soon after going to Washington I visited Charles Lang Freer in Detroit, a millionaire manufacturer of railway car wheels, who had been a patron and friend of Whistler. Freer possessed the largest collection of Whistler's works, including his famous Peacock Room, and also a collection of oriental art which is among the greatest in the world. The previous year these magnificent collections had been, under Presidential pressure, unwillingly accepted by the Smithsonian Institution. When eventually the Freer Gallery was opened in Washington in 1923, four years after Freer's death, the contents were valued at seven million dollars!

During the week I spent with Freer at his Detroit mansion I photographed his Whistlers and oriental art treasures in colour on Lumière Autochrome plates, the first satisfactory colour process, which had just been commercially introduced. I was delighted with these early colour experiments, yet my greatest love will always be for monochrome.

One of my regrets was that I was too late to photograph Whistler, for I much admired his work, but this contact through Freer was some compensation, for he

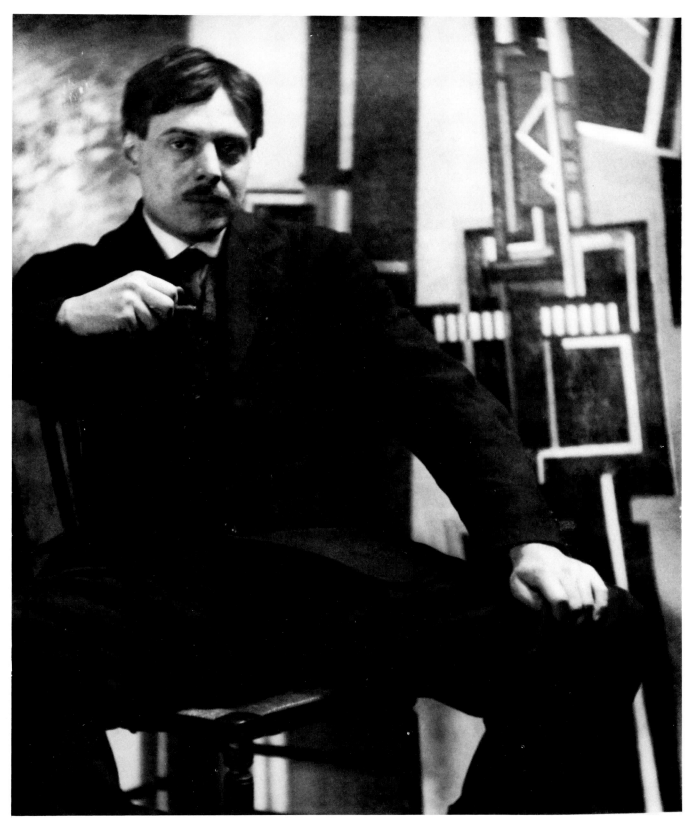

26. Wyndham Lewis. 1916

was very close to Whistler, who actually died in his arms. It almost seemed as if I had met the artist, for I became steeped in his atmosphere during that precious time with Freer in 1907.

A famous and typical American whom I photographed was "Mark Twain" (Samuel Langhorne Clemens). Who has not heard of *The Adventures of Tom Sawyer* and *The Adventures of Huckleberry Finn*? Certainly no small boy of my generation, or perhaps any other small boy reading English (or shall we say American?), or any other language into which these classics have been translated. It was, therefore, an especial pleasure to come into personal contact with the author of these and other humorous tales when *Harper's Monthly* magazine arranged for me to photograph him in the autumn of 1905. Imagine my disappointment when on ringing the bell at No. 51 Fifth Avenue the maid gave me the disconcerting news that the great man was in bed. Naturally I thought I should have to go away, but no, I was invited into his bedroom. There lay Mark Twain in a wonderful old carved four-poster bed, wearing a red dressing-gown and looking, with his wealth of flowing white hair, the real old lion that he was. He explained that he spent much time in bed because he could work there better and more comfortably. If he didn't want to see anyone, they could truthfully be told that he was in bed, but if he really wanted to see them, as in my case, he could receive them in bed just the same! This was said with a twinkle in his eye, and I could see that, like most humorists, he enjoyed his own jokes.

Mark Twain was, however, more than just a great humorist; he was as well a great personality, a truly great man. Although over seventy on this, to me, memorable occasion of our first meeting, he did not really seem old at all. He had the gift of perpetual youth. He did not so much talk with you, as take you into his confidence and impart to you some of the rich experience of his life; for the moment you were the only person in the world for him.

I always preferred to have a preliminary talk with my prospective sitter, and in this instance my wish was fully granted. I told him that I had been brought up on *Tom Sawyer*, which pleased the author as much as if he had never been told this before. By talking about the book my own enthusiasm and his ever-youthful joy in life were rekindled. We had a very happy time together, I made my photographs, and so ended our first meeting.

Three years later I had a fuller opportunity of knowing and photographing Mark Twain. My friend Dr. Archibald Henderson, Professor of Mathematics at the University of North Carolina, and biographer of Bernard Shaw, was engaged upon a life of Mark Twain, and had been invited to visit him at his new home "Stormfield" at Redding, Connecticut. I also was included in the invitation so that I might make illustrations for Henderson's book.

"Stormfield" was named from the author's satire *Captain Stormfield's Visit to Heaven*. It was completed in the summer of 1908, and it was just before Christmas that our visit took place. I was told that Mark Twain did not see the house until

27. Ezra Pound. 1916

it was completely finished "and the cat purring on the hearth-rug". What a peaceful place it was, with a suggestion of Italy about the garden with pergolas and fountains which even the snow could not wholly dispel. Outside it might be cold, but central heating augmented by great log fires on open hearths amply warmed the big house. Above all, there was the warmth of a homely and unstinted welcome.

The interior decoration of "Stormfield", largely the choice of Mark Twain's daughter Clara, the wife of the eminent pianist Gabrilowitsch, was very simple for those days of over-elaborate interiors. The walls were plain white or in pastel colours, the furniture austerely "modern", and there were few pictures or ornaments of any kind. Photographically it provided ideal backgrounds to the figure of Mark Twain, dressed in white because it matched his hair. (Plate 10).

Fine mornings—and most of them were fine—were spent in photography. Mark Twain seemed never to tire of being photographed both indoors and in the Italian garden, where he wore a long fur-lined overcoat and a white cap with flaps to cover his ears if required. I remember that he carried a long staff resembling a ceremonial wand. One photograph I especially recall. There was a circular basin of a fountain under one of the pergolas which was eventually to have a statue in it. Mark Twain asked, "Why should not I be the statue?" and mounted the pedestal, cigar in one hand and staff in the other, an erect and dignified figure. The sun shone on the background of snow-mottled yew trees, and thus was made a unique picture of Mark Twain as a living statue!

Most afternoons we played "pool" or billiards, at which he displayed considerable skill. An important rule of the household, which was secretly imparted to newly-arrived guests, was that the host must always win, but by the narrowest margin so as not to be too obvious! In these pastimes I was incompetent, but when we played the simple card game "Hearts" I was only rescued from the unpardonable mistake of winning, by the raised eyebrows and friendly nudges of the other players! I am quite sure that Mark Twain was not aware of this little device. He played with tremendous enthusiasm, as though his very life depended upon the result. After an especially brilliant stroke at billiards he remarked that one of his mottoes in life was "Nothing succeeds like excess!" I have often pondered on this curious trait in his character. It was far more than an ordinary desire to win: it was a kind of obsession. It was not that he was in his "second childhood" and had to be humoured. His mind was keen and active in this as in other matters, and he took a vivid interest in questions of the day, in art and politics. No, it was just that he wanted to win so eagerly that it was a positive pain for him not to do so. To see his intensity and determination as he leaned over the table, his face pink with excitement, was to understand something of why he *had* succeeded in life—succeeded in making himself world-famous in his chosen field. And the curious thing about it all was that it was actually more fun to see him win than to win oneself. I can still see his beaming countenance at the end of a "closely fought" and triumphantly won game.

66

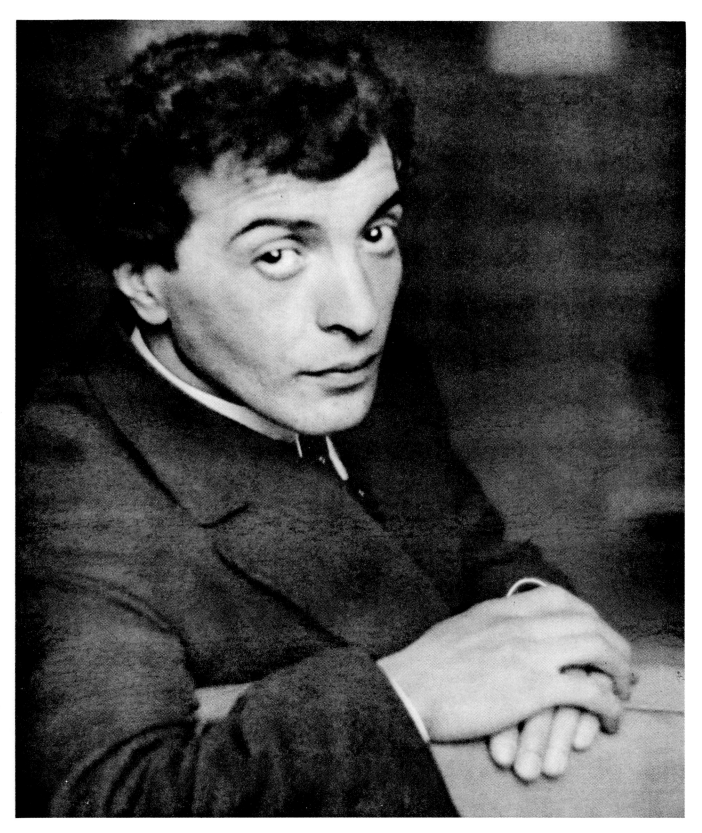

28. Benno Moiseiwitsch. 1916

I am sure Mark Twain felt a similar enjoyment in literary success as he did in winning games. Recognition of his greatness was "such fun" that everyone was delighted to acknowledge it. He wore the mantle of his fame so graciously and joyously that it was inevitable that he should be universally acclaimed.

In the big drawing-room there was a grand piano which Gabrilowitsch played in the evenings, and his wife sang. I remember how her father sat drinking in the melody with an expression of perfect contentment.

Not long before my visit burglars had broken in and stolen the silver. In consequence a framed notice was conspicuously displayed:

"To the next Burglar.
There is nothing but plate-ware in this house now and henceforth. You will find it over in the corner by the basket of kittens. If you want the basket, put the kittens in the brass thing. Do not make a noise, it disturbs the family. You will find rubbers [galoshes] in the front hall, by the thing which has umbrellas in it. Please close the door when you go away.
 Yours very truly,
 S. L. Clemens."

Mark Twain enjoyed being photographed and I must have made thirty or forty negatives during that December week-end. A few I took in colour on Lumière Autochrome plates. Ten of my photographs were reproduced in Dr. Archibald Henderson's biography of Mark Twain. Under one portrait the author wrote: "This is the best yet. Mark Twain." (Plate 10).

Towards the close of his life there was an unfounded report of his death. When it reached the author, he caused to be circulated the statement that "the rumour was grossly exaggerated." But the end came not long after my last photograph of him was made, for he died at "Stormfield" as the sun sank into the west on the evening of 21st April 1910.

Samuel Langhorne Clemens was born in 1835 and I am still alive in 1965, so between us we cover a span of 130 years, and it is quite astonishing the things that have happened during that period. The whole tempo of the world has changed: motor-cars, aeroplanes, man-made satellites, wireless, television, and above all atomic power, have made the world an amazing place in which to live. There are people who believe that all machine-made things are necessarily bad, that the old ways are best, and who with many head-waggings declare that the good old days will never come again! This is manifestly absurd, for if there had been no progress we would still be living in caves instead of houses, and scratching with a stick in the dust instead of using the latest kind of reflex camera! Truly useful things are usually beautiful, even the ordinary utensils of daily life; and when we come to such wonderful modern inventions as dynamos and aeroplanes, are they not marvels of beauty? They are as beautiful as a problem of Euclid, as beautiful as the idea of them that first evolved in the minds of the men who, one by one, contributed to their final perfection. But I think we must appreciate that in spite of all these remarkable inventions the human soul has not changed. It is still immortal, and this is

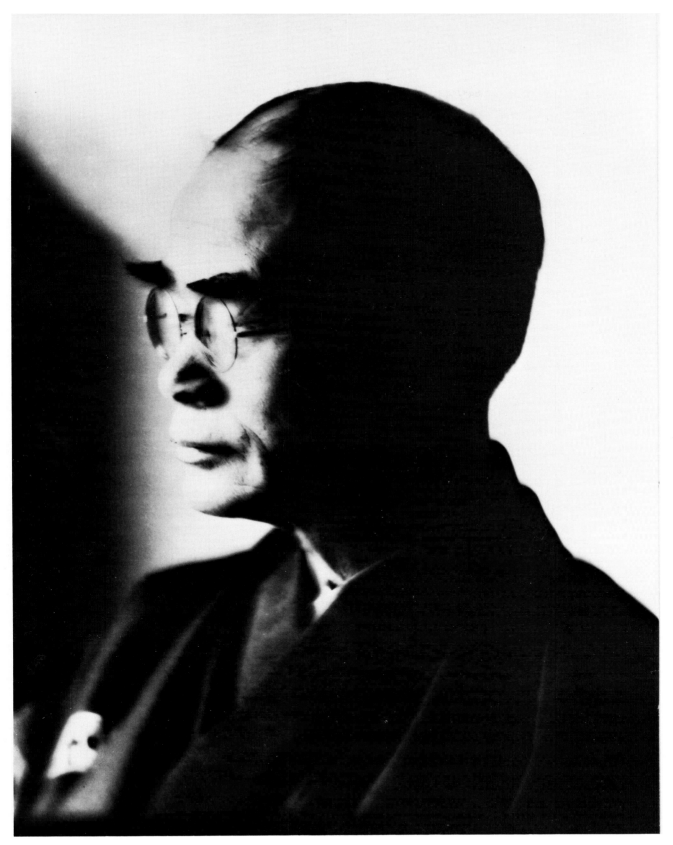

29. D. T. Suzuki. 1936

a consoling thought to me amidst all our material uncertainty.

After a sitting with William Orpen in January 1908 we talked about art and literature, and it transpired that he knew George Moore and W. B. Yeats and was going to Dublin at the end of the month, and if I cared to come too he would try to get them to sit for me. Everything was arranged quite informally in the genial Irish way and in a few days' time we went. I was so pleased when Orpen told me we were to go to George Moore's for dinner the evening after our arrival. During the meal there was much amusing talk between Orpen and Moore, with myself listening fascinated. After the coffee I showed my portfolio and George Moore consented to be photographed next day. He said he had made a solemn resolution never to do two things: be photographed, or make a speech at a dinner, and now that he had broken his resolve upon one point, he probably would on the other as well. I was very glad of his consent, for I was a great admirer of his prose, and the next morning I spent in making a number of negatives.

The same evening I was invited to a dinner party given by Lady Gregory to Hugh Lane to honour the opening of his Dublin Art Gallery. I sat directly across the table from W. B. Yeats, who wore a velvet coat and flowing black tie, and thus had an opportunity of studying him. After dinner he recited one of his poems, seeming hardly conscious of the people as he spoke. What he did would have been a pose in anyone else, but with him it was quite natural, for Yeats was a real poet. The next morning I was given a sitting. Remembering the dramatic quality of the poem at the dinner party, I asked Yeats if he would again recite for me while I photographed him. Without hesitation he began on some beautiful lines, while I flared a magnesium flash-light at intervals (Plate 11). The result pleased him, for he wrote to a friend: "Coburn, who understands photography, is celebrated in our world." I always tried to meet each new problem in portraiture as it came to me, and to solve it as best I could, and this seemed the most fitting way of getting the effect of speaking in the portrait of Yeats. A motion-picture would perhaps have been better. I have often thought I would experiment in this direction. How interesting it would be if I had cinematograph films of all the great men I have photographed during my life! Then from such a large number of negatives one or more could be selected for printing.

In 1916 I made a series of photographs of Yeats's No Play *At the Hawk's Well*, for which masks were designed by Edmund Dulac*, and Michio Ito, the Japanese dancer, played the leading role of the Hawk. I remember hearing about how Yeats and Ito went to the London Zoo to study the postures of the hawks there, and Ito amazed the visitors by performing a dance for all to admire, especially Yeats. One can imagine this pleasing picture of these two unselfconscious artists completely

* Dulac made caricatures of people he liked, and little doll-like figures of those he disliked. I am glad to say that I belonged to the former category.

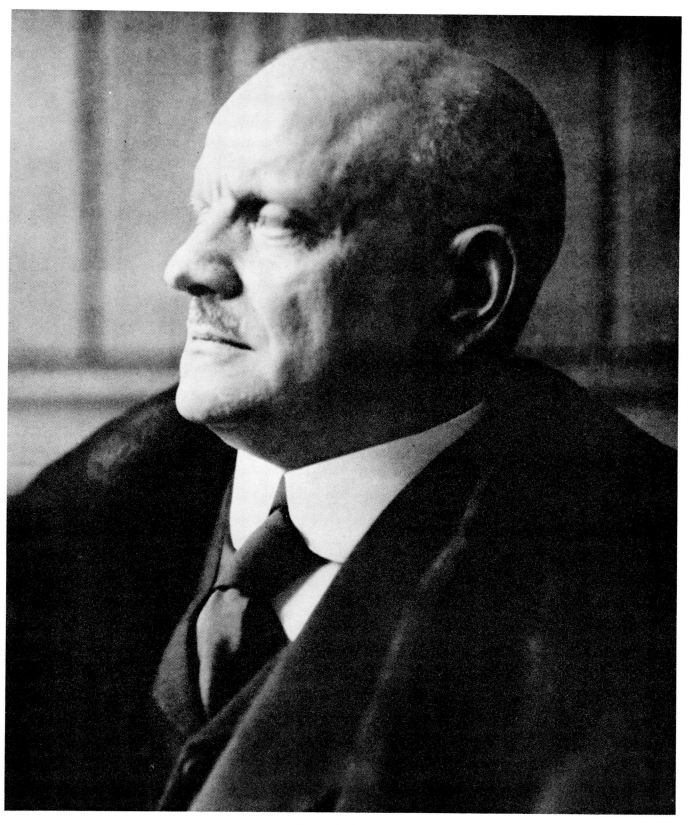

30. Jan Sibelius. 1918

oblivious that there was anyone else in the world beside themselves. They were like two children in their delight.

My first meeting with Hilaire Belloc took place in January 1908, the same month that I photographed Yeats. Belloc came dashing up in a taxi, fresh from a debate in the House of Commons, with a pocket full of papers and a head full of ideas. He talked to me about many things, made pleasant comments on some of my pictures, and then whisked away in the cab which he had kept ticking at the door. I have been told that Belloc could dictate a three-hundred-page novel in a week—altogether a most extraordinary man (Plate 12). When my prints were ready he invited me to tea at the House of Commons. It was a novel experience to sit on the terrace along the river, with the great stone towers and turrets rising up behind me, in such distinguished company.

In 1914 Belloc suggested that I should make a series of photographic illustrations to his book on the Pyrenees, and he worked out exactly what they should be, and the inns I should stay in during my tour from coast to coast. I made a most delightful journey by map through this wonderful mountain range which divides France from Spain, but alas! the first world war was declared, so the project never materialised, to my great disappointment. One thing, however, was impressed upon me—that a journey in the imagination under the guidance of such a man as Belloc may be a very real experience, almost as real as a physical journey.

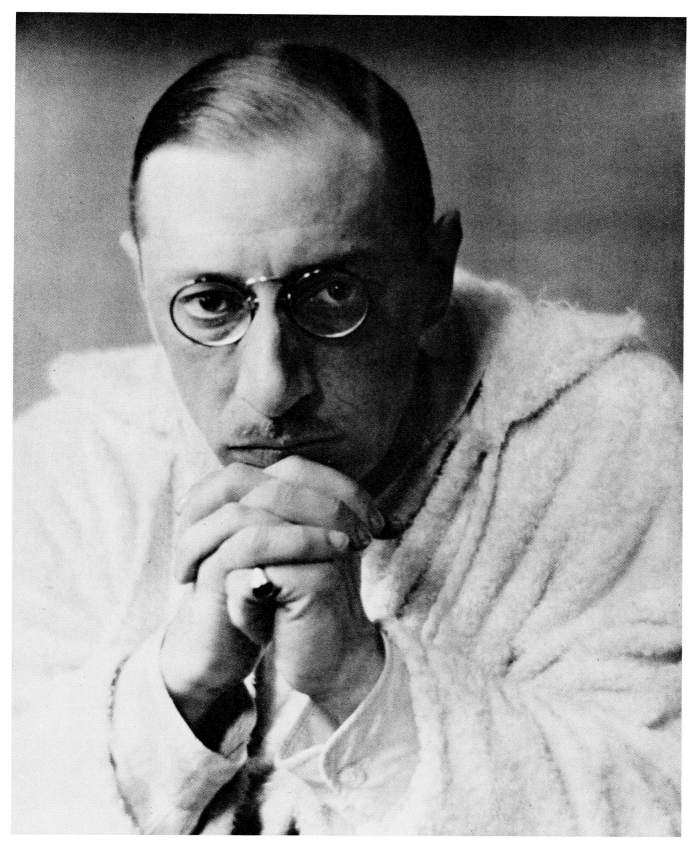

31. Igor Stravinsky. 1921

VII. Photogravures

FOR THREE YEARS FROM 1906 onward, whenever I was in London I used to go twice a week to learn the process of photogravure at the London County Council School of Photo-Engraving in Bolt Court off Fleet Street near the haunts of Dr. Johnson. After our labours we often repaired to the "Cheshire Cheese" to refresh ourselves with the famous old-English dishes of that ancient establishment.

When in March 1909 my mother and I left the apartment in Guildford Street where we had lived whenever we were in London, and moved into "Thameside", a charming old house in the Lower Mall at Hammersmith which we had bought, I set up two printing presses in addition to studio and darkroom.

There was only a footpath between "Thameside" and the river. The studio had a 15-foot long window looking out on the river, where great barges with red sails came up and down the Thames with the tide, and of which I made many pictures. The house was close to Hammersmith Bridge, offering an excellent view of the annual Oxford and Cambridge Boat Race, and it was truly remarkable how many friends we seemed to have on the day of that exciting event.

So far, my photographs had been published only in other people's books and in magazines, but later this year, 1909, appeared my book *London* with twenty plates. The introduction by Hilaire Belloc concerning the city completely ignored my pictures! In going through my papers recently for my autobiography I discovered among my numerous Shaw documents a foreword by him, which for some reason the publisher had not wished to use, and it is printed here for the first time.

"This collection of photographs of London has been in preparation by Mr. Coburn for the past five years; but technically they represent the latest development of his art. His reputation as a master of photographic printing has been gained by single prints in gum and platinotype, each of which cost more to produce than all the prints in this volume. He found it impossible to hand over his negatives for reproduction by commercial processes without losing the personal qualities on which the artistic value of his work depends. Recognizing nevertheless that in photogravure Commerce has produced a method capable of rivalling mezzotint in the hands of an artist, he set himself to master this process also; and he has now, as the impressions in this volume shew, won the same command of it as of his earlier methods, and can not only produce prints comparable to his finest achievements in gum-platinotype, but reproduce them with a certainty at a cost which makes such a publication as the present possible.

"The photogravure plates from which the pictures have been printed have not been made in a factory from Mr. Coburn's negatives, but by his own hands. Every step in the process has been carried out by himself in his studio with the artistic result aimed at constantly in view, thus placing the process on the artistic footing of etching, lithography and mezzotint.

"Like Whistler, Mr. Coburn has the advantage of looking at London much more imaginatively than any born Londoner could. What he shews us is there, as the camera testifies; but few of us had seen it until Mr. Coburn shewed it to us."

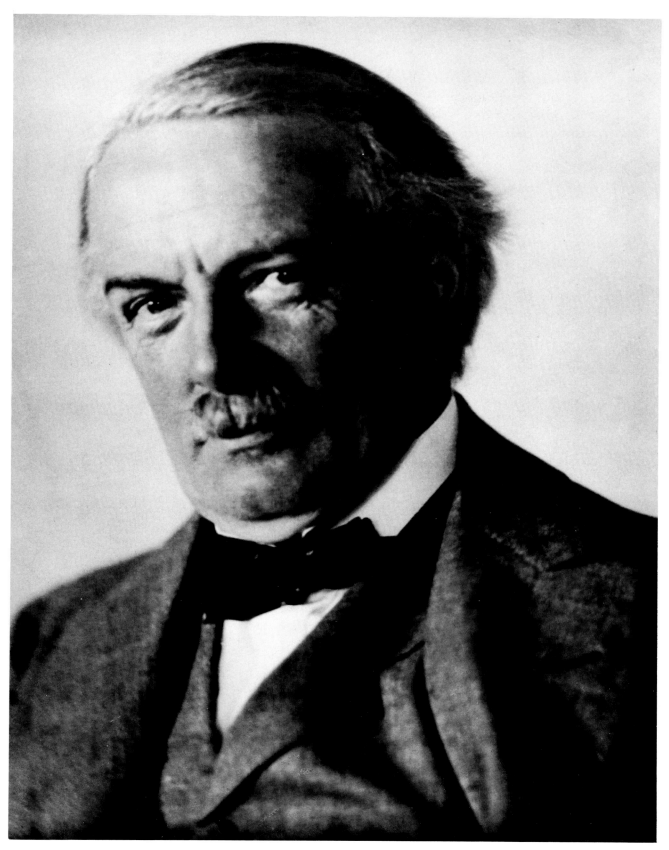

32. David Lloyd George. 1918

With the manuscript was enclosed a card on which was written: "Will this do? Cook it as you please. G.B.S." I wish that this very understanding bit of writing might have been used for my London book instead of the Belloc text.

On my own presses at "Thameside" I produced over a period of many years the photogravure illustrations of my books *London, New York, Men of Mark,* and H. G. Wells's *The Door in the Wall.* "The Copper-Plate Press", my self-portrait (Frontispiece) is a testimony to the operative quality of my work in this field. I think I may claim that in my hands photogravure produced results which can be considered as "original prints", and which I would not hesitate to sign. Quality of reproduction in a photograph is so *very* important. *More Men of Mark* was printed commercially in collotype, and it is only necessary to compare the two *Men of Mark* volumes to see the difference. (Incidentally, I originally intended the title to be *Men of Genius* but Arnold Bennett objected seriously, saying modestly that he did not consider himself a man of genius but merely a working author, and absolutely refusing to join the throng to be represented unless I changed the title. I told Bennett that if he could give me a better one I would use it. *Men of Mark* was his alternative, and this suggestion was but one of his kindnesses to me.)

Photogravure is printed by inking a photographically-engraved plate, wiping off the excess ink by hand, laying damped paper on the plate, and passing it through a copper-plate press. The printing method exactly resembles that of mezzotint engraving.

I prepared the printing plates myself, by etching and steel-facing them; I ground the inks, and pulled proofs on various grades of paper until I had a specimen for my printer to follow. The comparatively soft copper will not stand up to a run of 500 copies unless it is steel-faced, i.e. electro-plated. My printer, of course, was only concerned with pulling the paper prints and was unable to re-face the plates, and it seemed that whenever I went away the facing was inclined to wear thin, so I was obliged to remain in attendance for many years. It was a considerable relief when at last the four books were finished. They totalled 83 plates and over 40,000 printed copies. In addition, I produced six 15″ × 12″ plates of landscapes, from which a limited number of prints were run off. I wish that I might have continued to operate my own copper-plate presses, but the work was far too exacting. No-one will ever know save those who have experienced it, what such an undertaking involves.

In 1910 my second book was published: *New York,* containing twenty original photogravures from my own press, and an appreciative introduction by H. G. Wells.

"Posterity will owe much to Mr. Coburn, so that I hesitate to call the series of studies he has made of the beauty of contemporary cities the chief thing for which his memory will be honoured; but certainly his record of urban effects will be a greatly valued legacy. Our time will go to our descendants heavily and even over-abundantly documented, yet I still fancy these records of atmosphere and effect will gleam, extremely welcome jewels, amidst the dust-heaps of carelessly accumulated fact with which the historian will struggle. Mr. Coburn has already done his share in recording that soft profundity, that gentle grey kindliness, which makes my mother London so lovable, that tenderness which otherwise will

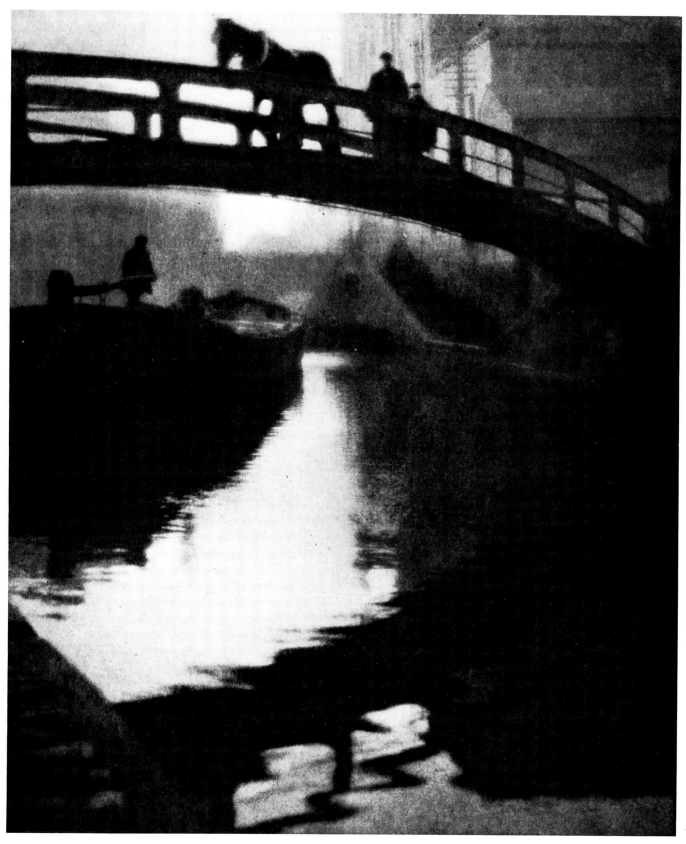

33. Regent's Canal, London. 1904

seem so incredible in an age that will know nothing of carbon-laden fog-veils and sooty bricks and the blackened stems of trees against the spring. And now here he has set himself with the finest discrimination to give in a compact volume the hard, clear vigour of New York, that valiant city which even more than Venice rides out upon the sea.

". . . . I will confess an unqualified admiration for the sky-scraper—given the New York air to reveal it clearly to its summit against the sky. The Flat-Iron I visited again and again during my brief stay in New York, that I might see it at every phase in the bright round of the New York day and night. Mr. Coburn has given it between wintry trees and in its graver mood (Plate 51), but I liked it best in the pellucid evening time, when the warm reflections of the sundown mingle with the onset of the livid lights within. To suggest that, the most exquisite of all New York's daily cycle of effects, Mr. Coburn has given a picture of the Singer Tower at twilight, in which I verily believe his plate has caught something of the exhilaration of the air. When I look at it, I am back in New York again: I become energetic beyond my London habit, I am moved to call one of those extravagant cabs where fares seem higher to an Englishman than even the sky-scrapers of this altitudinous city—and go out to dinner with high-rented, high-pitched, clear-speaking, hospitable people forthwith."

Wells ended: "A hundred years hence people will have these photographs, but I wish Mr. Coburn could show me pictures of New York in a hundred years from now."

Even in 1910 New York was a remarkable place, and I am glad to have recorded it as it was then. The New York book is, I believe, now quite difficult to find, but I often look at my own copy with considerable pleasure, for it brings back to my mind many precious memories of the past.

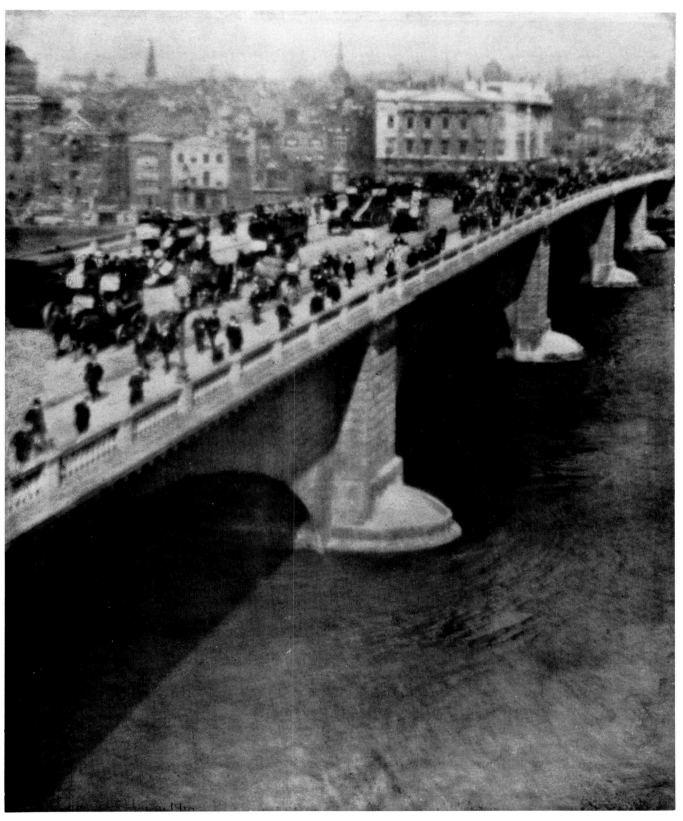

34. London Bridge. 1905

VIII. American Photographs and Experiences

AFTER A TRIP TO IRELAND for Bernard Shaw in connection with a book we planned to do on "How to Solve the Irish Problem"—which never materialised—I set sail once more for America in the autumn of 1910, reaching Buffalo early in November, just too late for the opening of an important Photo-Secession show arranged by Stieglitz at the Albright Art Gallery. This was the first American art museum to show photographs, and in 1915 I arranged there a small exhibition of Old Masters of Photography, consisting of my own prints of their work. The pictures of the great Edinburgh photographers David Octavius Hill and his collaborator Robert Adamson, and Dr. Thomas Keith, were printed by me from their original paper negatives; those of Julia Margaret Cameron and "Lewis Carroll" were from copy-negatives I made from their original prints. At that time, the work of these Old Masters was little known. During the past fifteen years or so their photographs have been brought before the public in numerous exhibitions and publications, foremost by the photo-historians Helmut and Alison Gernsheim.

During the winter of 1910-11 I took a series of photographs of Pittsburgh (Plate 42) with the idea of publishing a book. Snow lay on the ground, making the grim city a very dramatic subject, and I spent many happy hours among its factory chimneys and barge-haunted rivers. The mysterious veiling of smoke-laden atmosphere lent an undoubted charm even to the partial obscurity of the winter sunshine.

I have photographed in many industrial cities both in America and elsewhere, always with enthusiasm and interest. Photography makes one conscious of beauty everywhere, even in the simplest things, even in what is often considered commonplace or ugly. Yet nothing is really "ordinary", for every fragment of the world is crowned with wonder and mystery, and a great and surprising beauty. Only recently I visited the mill districts of Yorkshire, and it would take very little persuasion to entice me there to record, perhaps even to endeavour to idealize, some of its dramatic valleys. Who knows, it might be possible for me, even now at the age of eighty-two, to venture upon such an undertaking.

The following spring and summer I spent several peaceful months camping in the lovely Yosemite Valley, California—one of the world's finest beauty spots. The long focus lens I used on Half Dome (Plate 44) gave, I think, an exceptionally dramatic rendering of this remarkable natural phenomenon. It has been my privilege to present my camera to very many things which have caused me to experience true wonder, and this is one of them, and I firmly believe that if we make the most of

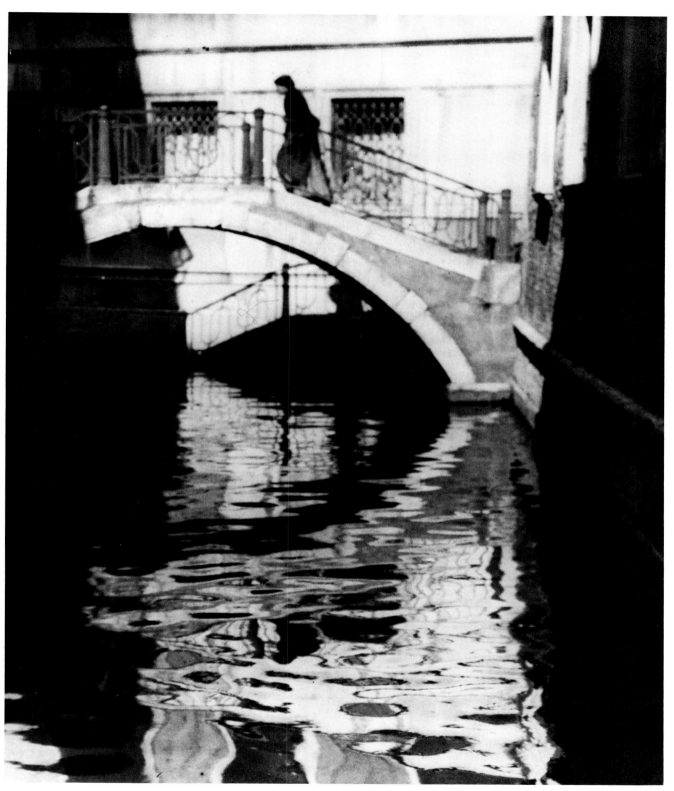

35. Shadows and Reflections, Venice. 1905

our opportunities we shall be granted further visions. If we turn our backs on beauty and grandeur, we shut the door to further loveliness, but if we seek and find wonder after wonder, still greater experiences come to us.

If this is true of natural grandeur, what can we say of beauties which are beyond these things, and visible only to the soul itself? There is an essay entitled "On the Beautiful" by that great Greek mystic Plotinus, in which he leads us from the beauties of nature, through more and more spiritual types of beauty to the Beautiful Itself. This is an ascent of the most satisfying kind.

While in California before going to Yosemite I climbed Mount Wilson, site of the famous observatory. My purpose was more to enjoy the beauty of the scenery than to look at the stars, although I did see the moon more closely than at any other time through the gigantic telescope. I believe it had the largest mirror in the world in the year 1911. Among other things, the astronomers were then experimenting with infra-red plates, and while I was there several stars were discovered never seen by human vision!

It was a novel experience to bathe in the warm sea at the Californian coast in the morning, climb the mountain in the afternoon, and walk in deep snow in the evening!

Mount Wilson had to be ascended on horseback, and it was fairly late in the afternoon when my first upward journey was made. I lingered to photograph the sunset, when suddenly the clouds came down and obscured everything. I knew that the instincts of my horse were much more reliable than my own, so relinquishing the guiding reins, I gave my mount a gentle pat on his side, and he quite easily found his way to the stable at the top. In the morning the glory of the landscape was a wonderland never to be forgotten, and I spent many happy days in this photographic paradise (Plate 45).

In September I went down to the Grand Canyon in Arizona, one of the most impressive natural wonders of the world. It always makes one feel very insignificant to be brought face to face with such marvels. Even ordinary landscapes are remarkable, but the supreme examples of exceptional magnitude are unforgettable. The spectacular canyon is 200 miles long, a mile deep, and from five to fifteen miles wide in its upper section. No words can describe its grandeur. The camera can give us hints, but only hints, and even with the reality before us it is hardly possible to believe one's eyes.

The Grand Canyon is a fantastic place, full of legends. One tells of a tribe of Indians who claimed to be able to walk out on the air where the original earth had been before the canyon had been formed by the Colorado River. Prepared by strange rites, they walked out into nothingness. Once a white man wanted to accompany them, with an Indian on either side to support him. He insisted that he had the faith to do it, and they started out together after the rite had been duly performed but the two Indians returned without the pale-face. His faith did not stand the test!

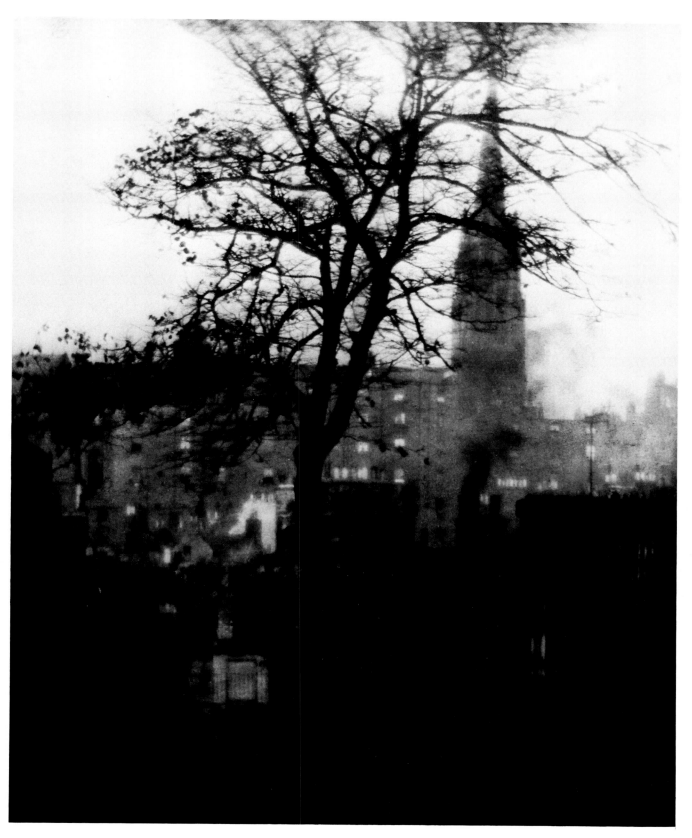

36. A tree in Greyfriars Churchyard, Edinburgh. 1905

At the time of my visit many places in the Grand Canyon had never been seen, but now, of course, it can be viewed by air, though this is not the same as the wonder and excitement of exploring it on foot as I did. I went to places where I believe no human being had ever before visited or photographed, and the picture of the Great Temple (Plate 46) is an experience I shall never forget. It was a day of fast-moving clouds racing before the sun, and casting shadows, alternately concealing and revealing. In a moment all would be changed. I saw this picture, and then it was gone, but I had patience and waited for its return, when the Great Temple itself would be dark against the sunlit wall of the Canyon beyond. How overjoyed I was when at last the effect came again!

I spent many months sleeping under the open sky, and living in very primitive conditions. When I crawled into my sleeping-bag I had to encircle myself with a horse-hair rope to keep out the rattle-snakes. Horse-hair tickled them, so they left you alone. My old guide John collected and sold snakeskins of the most beautiful colours matching the varied strata of the rocks—red, green, purple and yellow. Food and water were a constant problem. Everything had to be carried on mules, roped together one after another along the narrow trails down the face of the Canyon. Sometimes the ropes got tangled up with one another, but it was all part of the adventure. To cross the Colorado River at the bottom of the Canyon there was a hand-propelled cage slung on a cable, and on reaching the other side it was necessary to catch *wild* donkeys to continue the journey! It is all very different in these days of tourism, and I certainly photographed the Grand Canyon the hard way. At least, I was now using a smaller camera, a $3\frac{1}{4}'' \times 4\frac{1}{2}''$ reflex.

I returned once in winter to see the wonders of the Grand Canyon in snow—a glorious sight. Venturing out on a ledge to get a certain picture, suddenly my foot went through what I had thought to be rock, but which proved to be ice through which my foot had penetrated, and there, thousands of feet below me, was the chasm! I crept back to safety, but it was a nerve-shattering experience.

Fascinated by the natural views from high altitudes such as Mount Wilson and the rim of the Grand Canyon, the following year I photographed equally fascinating though quite different man-made views from the top of New York's skyscrapers. "The Octopus" (Plate 48) was taken from the top of the Metropolitan Tower, looking down on Madison Square where the paths formed a pattern reminiscent of that marine creature. At the time this picture was considered quite mad, and even today it is sometimes greeted with the question "What is it?" The answer is that it is a composition or exercise in filling a rectangular space with curves and masses. Depending as it does more upon pattern than upon subject matter, this photograph was revolutionary in 1912.

" 'The House of a Thousand Windows' " (Plate 49) "is almost as fantastic as a Cubist fantasy", I wrote in the catalogue of my exhibition at the Coupil Gallery in Regent Street, London, in 1913, "but why should not the camera artist break away

84

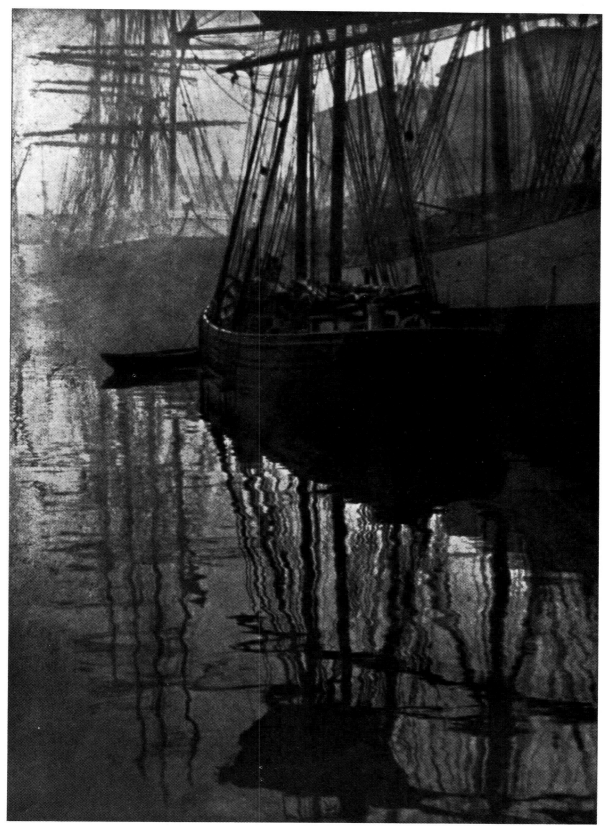

37. "Spider Webs", Liverpool. 1906

from the worn-out conventions, that even in its comparatively short existence have begun to cramp and restrict his medium, and claim the freedom of expression which any art must have to be alive?" One section of the exhibition was entitled "New York from its Pinnacles", and of this I wrote: "These five pictures were made from the towers of New York's highest buildings. How romantic, how exhilarating it is in these altitudes few of the denizens of the city realize."

The plate of the Singer Building, Twilight, New York (Plate 50) was a favourite of H. G. Wells and was one of the prints of mine which he hung in his dining room. The lines connecting the lights were made by passing trams, and I believe they improve the pattern.

In an article written in 1916 on "The Future of Pictorial Photography" I asked: "Why should not the camera also throw off the shackles of conventional representation and attempt something fresh and untried? Why should not its subtle rapidity be realized to study movement? Why not repeated successive exposures of an object in motion on the same plate? Why should not perspective be studied from angles hitherto neglected or unobserved? Why, I ask you earnestly, need we go on making commonplace little exposures of subjects that may be sorted into groups of landscapes, portraits and figure studies? Think of the joy of doing something which it would be impossible to classify."*

The sky-line of New York is very different now from what it was in 1909 when Plate 43 was taken, but Brooklyn Bridge remains, I understand, much the same. The little tug-boats are also, I expect, not greatly changed, with their puffs of smoke to add additional interest. Photography and marksmanship have something in common. What would this picture be without the little tug-boat? It gives the scene scale, and makes it alive.

I wonder if I shall ever go over again to see what has happened to this fantastic city? Of course, I have seen other people's photographs of New York, but that is not the same as seeing it for oneself or especially of photographing it oneself.

I sometimes wonder what H. G. Wells would think of it now? He saw in his imagination many visions of things to come, and what will another fifty or a hundred years bring us? We can look back to the past, but only in our inner vision can we imagine the future.

The Flat-Iron Building is one of the most remarkable structures in New York, and has been the subject matter of many famous American photographers. Stieglitz idealized it in a snow-storm as long ago as 1902, and I could not resist following in his footsteps ten years later when I photographed it at twilight (Plate 51).

During this stay in New York I married my beloved Edith Clement of Boston on 11th October 1912 in Trinity Church in Twenty-fifth Street. Only my mother and the verger were present as witnesses. Over and over again I rejoice in the memory of this event, and our return together to this side of the Atlantic, and our

* *Photograms of the Year,* 1916.

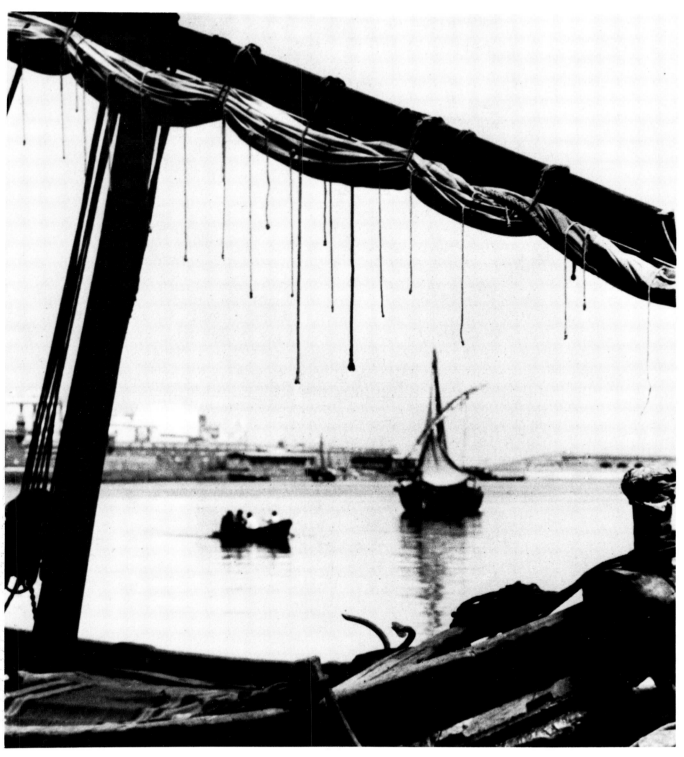

38. Cadiz Harbour. 1906

happy and continuous sojourn here together—for I never returned to the land of my birth. The evening before, we attended a party at which many photographic friends were present, but did not mention our prospective wedding as we considered it an entirely personal matter. A few days later, however, I asked my friend Clarence H. White if he would make a series of photographic prints of the two of us together, to commemorate this to me most lovely event in my life. White was probably one of the most distinguished members of the Photo-Secession, and I think if I were asked to name the most subtle and refined master that photography has produced, that I would name him. Accordingly, nine days after our wedding, Clarence made a fairly extensive series of photographs of Edith and myself during a motor excursion up the Hudson River. It was a glorious day, unusually warm for late October, a spell of Indian Summer, and the results are a lovely memory. The pictures fully justified my expectations of White's ability and discrimination. To be a true artist in photography one must also be an artist in life, and Clarence H. White was such an artist.

At this period I was far from well. How my wife (bless her) had the courage to marry me I often wonder, but she did, and I survive her and am still able at the age of eighty-two not only to cope with life but also to publish this book!

Concerning my dear Edith (Fig. 3), wife and sweetheart, what can I say? She was the most unselfish person I have ever known, and what I ever did to deserve the forty-five years of happiness spent in her blessed company I will never know. She was always thinking of what she could do to make others at ease. Her sympathy and understanding were faultless. She would look at you with her lovely quizzical smile and disarm your retort, and she was never by any possibility unfair.

Edith was not pretty, but she was a beautiful character, kind and wisely discriminating. She did not especially enjoy being photographed, but she would submit gladly and graciously to the ordeal if she thought she could help me solve a problem in composition.

She loved children and animals, and they in their turn appreciated this and responded to her love. She did not have any children of her own, but she would have made a lovely mother, and much of her maternal feeling was lavished on this unworthy little boy, which I did my best to appreciate.

39. Faubourg St. Germain, Paris. 1906

IX. More Men of Mark

THE BEGINNING OF THE VISIT of my wife and myself to Paris the spring following our marriage was really a continuation of our honeymoon. It was all very romantic and lovely to remember. We lunched at Versailles or Fontainebleau in the sun under trees, with leaf-dappled shadows on spotless linen.

From one of the towers of Notre Dame, high up among the gargoyles, I took a vista of Paris roofs (Plate 52) which gave me great pleasure in the making and also seems to delight others. I am glad of this, as it is one of the joys of the artist to share his vision with others for their mutual pleasure. When this print of Paris roofs calls forth, as it sometimes does, the remark that it reminds the beholder of an etching, I am inclined to retort that it reminds *me* of a photograph! No doubt the intention is complimentary, but I like to think that my work owes any merit it may possess to the integrity of the medium. I am proud of being a photographer. A photograph which deliberately attempts to pass as something else is unworthy and demeaning.

"I wish to state very emphatically", I wrote as early as 1913, "that I do not believe in any sort of hand-work or manipulations on a photographic negative or print.

"I would much rather have a hard, sharp, shiny, old-fashioned silver-print, which was an honest workmanlike article with no nonsense about it, than the modern trash, part photography, part very indifferent draughtsmanship . . . that fills the walls of many of our exhibitions of so-called artistic photography to-day . . . These photographs which are not photographs or anything else under the sun, do more harm to the cause of photography in its fight for recognition as an art, than the millions of quite bad snapshots which, after all, do not pretend to be anything except what they are: a quite innocent and usually harmless amusement."*

In Paris we visited Gertrude Stein (Plate 17), who I think has something to tell us which the world will come to appreciate, which many are now beginning to recognize, and which many in the future will value. It is breaking through in many arts, in words used for their tonal value, through music itself (all art is a kind of music—Pythagoras and Walter Pater told us long ago), and it is now coming to birth through sculpture and paintings, and perhaps even through photography? Words are symbols of things, but they are also sounds, and Gertrude Stein used them in both these ways. To find a new mode of expression in any form of art is an achievement and a triumph, and Gertrude Stein delighted in these fresh and spontaneous modes of approach. Through her I met and photographed Matisse, admired by us both, though it often takes a generation for a genius to be recognized. It is satisfying to recognize a great man or woman before the world does so! I never had any

* *Pall Mall Magazine*, 1913.

90

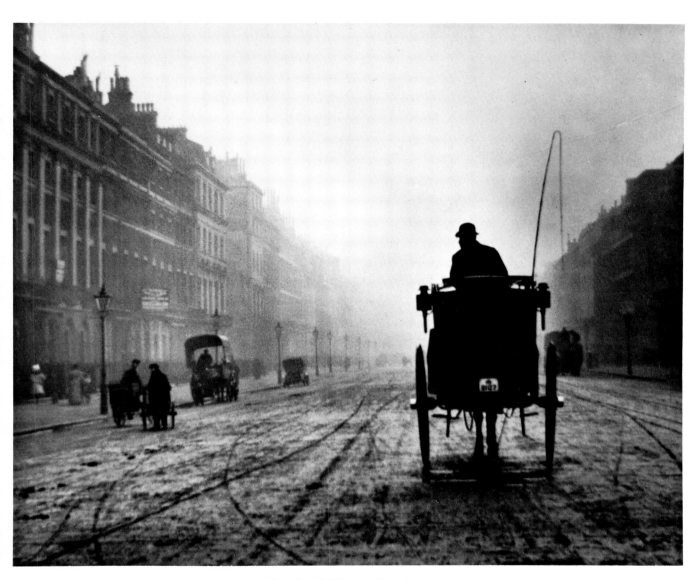

40. Portland Place, London. 1906

difficulty in appreciating the *avant-garde* in art, music, and literature.

It was through my friendship with the American Cubist painter Max Weber, a pupil of Matisse and Henri Rousseau, that I first came in touch with the Post-Impressionists. Weber had a freshness of view-point and a sincerity that give his paintings a unique quality. He was fond of studying the art of primitive peoples, as he found in it a kindred spirit. Weber had a sense of design that never failed him, and what is equally important, a beauty of colour vision; therefore, however revolutionary his ideas, he could not help producing pictures that have a lasting attraction.

Max Weber was also a poet, and in 1914 I arranged for the first book of his "Cubist Poems" to be published by Elkin Mathews in London.

I first saw the work of Henri Matisse in the second Post-Impressionist exhibition organized by Roger Fry and Clive Bell in London in 1913. The conventional critics poured abuse and derision upon him and his fellows, but time has reversed their decision. Art lovers used to worship what was termed beauty, and people came to think that beauty and art were synonymous, but the Post-Impressionists, the Fauves, and the German Expressionists have shown that art and what we may have thought was ugliness can produce a harmonious and striking effect, for it is expression, not conventional beauty, which gives to art a power and to life a significance.

In the Post-Impressionist exhibition was a small picture in primary colours by Matisse of a bather on the seashore with her straw hat hung on a tree, which particularly attracted me, but it was a sketch and marked "not for sale". When I went to Matisse's Paris studio in May 1913, there was the little sketch which I had admired in the London show to greet me. I persuaded the artist to let me buy it, and for many years I rejoiced in its clear, bright, luminous colours.

My portrait of Matisse (Plate 18) gives me the same kind of pleasure that I experience when looking at his paintings. I cannot explain why, but this is so. It was taken just in time for inclusion in *Men of Mark*—the first book of which the text as well as the photographs and their reproduction was mine. I dedicated it to my mother. It is amusing to-day to see that I referred to Matisse as "so able and interesting an artist"! No doubt at the time most of the other thirty-two people illustrated in my book were better-known than he, whereas to-day some of them are no longer household names. I was, of course, aware of the probability of fluctuations of fame, and concluded my text: "It is difficult to write history while you are living it, and I am getting so close to-day in these last five portraits that I cannot get the proper perspective to write about them, as perhaps I will be able to do in ten years' time."

Another artist whom I photographed in 1913 was Frank Brangwyn (Plate 19). I had already made his portrait in 1904, and shortly afterwards joined him in his studio, working on still-life subjects and compositions. One of the most interesting times was when the short winter afternoons drew to a close and it became too dark to see colours, a few chosen spirits would sit around the stove to listen to "F.B." tell

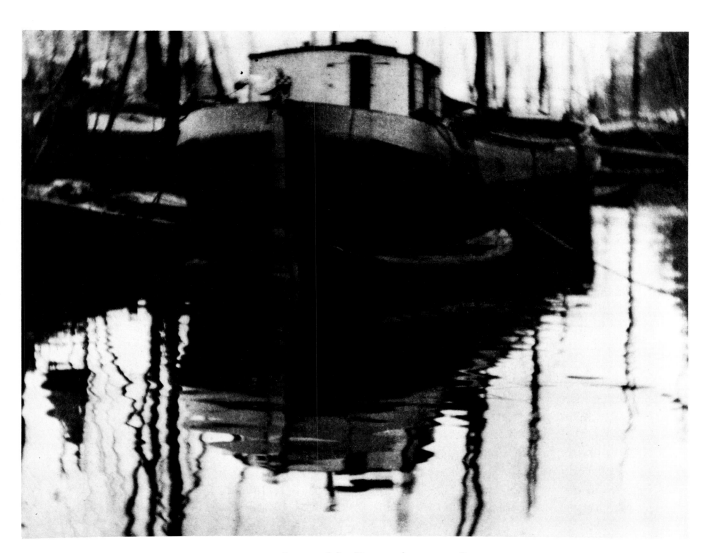

41. A canal in Rotterdam. 1908

stories of his wanderings, while we listened spellbound. As a young man he had been to sea, and his flow of nautical terms was remarkable, especially when he was a bit angry.

At one time I took up wood-engraving with Brangwyn, and the box-wood of which the blocks are made is an exceptionally hard kind of wood. You hold the block in your left hand and engrave it with a very sharp implement held in the right hand. With the beginner this instrument is apt to slip, and this indeed happened to me: it sank deep into the flesh between my thumb and first finger! Brangwyn roared with laughter, and escorted me to the bath-tub where I could bleed in peace, assuring me that I was now duly initiated into the craft of wood-engraving.

I think that this photograph was one of the best of the many I made of him. He appreciated the value of photography as do all good artists. My test of a painter is his attitude to photography. The really great ones do not fear its competition but welcome the artist-photographer and appreciate what he is doing.

I'm afraid there are still a few people who are antiquated enough to take exception to my calling photography an art. Many of them are indifferent painters who have been driven from the field of illustration by the precision and speed of photography. People may deride the camera in public, and secretly use it to aid their feeble drawing and lack of memory.

Jacob Epstein was another great and unique artist in his own field. I first photographed him on a very cold and frosty morning in January 1914. It was so gloomy that there was not enough light to see to focus in the house, so the sculptor put on a greatcoat and a cap with ear-flaps and we went up on the roof, where I photographed him among the chimney-stacks (Plate 22). It was so cold that it did not need much imagination to see the vapour coming from his mouth, even in the photograph. Between exposures we had to come indoors and try to get warm, and Epstein showed me some of his drawings and remarkable collection of South Sea carvings. At a later date I took other portraits of him, but never one that I liked as well as this, and I think he agreed in preferring it.

Personally I consider Epstein's work magnificent, especially his abstract sculpture. There are very few sculptors, living or dead, in his class at all. He was not conventional or orthodox, but these are often only other names for dullness and mediocrity.

I like the story how Epstein started on his St. Michael bronze for Coventry Cathedral because he just wanted to do it, before a contract was signed or even the fee agreed upon. Great artists are made that way, the inspiration is all-important. Art cannot be confined within boundaries, it comes to the call of the mood.

I cannot remember where I first met Augustus John, whether in a Soho restaurant or a Chelsea studio, but it was certainly in one or other of these bohemian settings, and it was Orpen who brought us together. We met several times before the actual photographing, and then at last one day in 1914 I went to his big studio

94

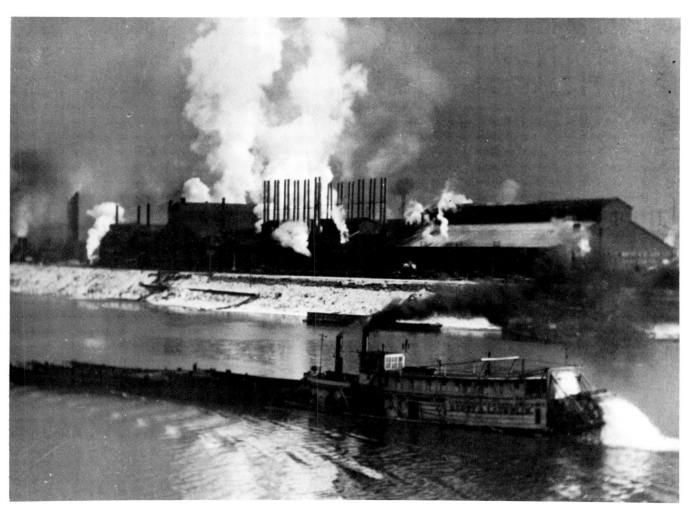

42. Pillars of Smoke, Pittsburgh. 1910

in King's Road, near Chelsea Town Hall, and made a large number of negatives. How could one help it with such a remarkably picturesque subject? (Plate 23). When I had made the prints I called again at King's Road, and I feel convinced that the artist was pleased with the results, for after looking at them he pointed in his abrupt but not unkindly manner to a pile of sketches on wooden panels in a corner, saying: "You'd better have one of these." I was not long in choosing, and John remarked approvingly that I had selected the best one!

Robert Bridges was made Poet Laureate in 1913, the year I photographed him.

His poetry had a luminous charm and he himself was very good to know, but perhaps one of his greatest claims to remembrance was his discovery of the poetry of Gerard Manley Hopkins.

Hopkins was a Jesuit priest, and he wrote poetry for his own satisfaction and that of his friend Bridges, to whom he sent his productions, but during his lifetime few of them were published. Hopkins died in 1889 but Bridges did not bring out an edition of his poems until 1918. I think he waited these twenty-nine years for the poetic world to mature to an appreciation of these very unusual poems, in many of which Hopkins employed what he termed "sprung rhythm". Even in 1918 the poems were not an immediate success, but in recent years Hopkins has come to be regarded as a poet of original and outstanding merit, and a profound influence in the poetry of our day.

Both Hopkins and Robert Bridges were also musicians, and in my portrait of Bridges he was actually playing the piano, which gives his face the expression of detachment which I find especially characteristic (Plate 20).

An enthusiast for the theatre, in 1910 I began photographing at rehearsals, scenes and characters in *Justice* by John Galsworthy, Meredith's *The Sentimentalists*, and Maeterlinck's allegory *The Blue Bird* with its fantastic costumes. I recorded a lively rehearsal by Shaw of one of his finest comedies, *Androcles and the Lion*, for its first production at the St. James's Theatre in 1913. As a rule Shaw produced his own plays but for some reason left *Androcles* to Harley Granville-Barker, whose wife Lillah McCarthy played Lavinia, and came only to the dress rehearsal. Considering that the entire cast was under-acting, G.B.S. countered this by outrageous exaggeration in his reading, and dominated the occasion by a demonstration of how a conflict in the arena should be fought (Plate 21). The rehearsal ended at 3 a.m.! *Androcles* had a remarkable casting for the lion-taming part: the actor O. P. Heggie, an Australian, had actually lived in a jungle with wild animals who failed to harm him! Shaw had an uncanny capacity for such a right casting of actors. Incidentally, Shaw and the actor playing the lion's part went to the Zoo to study the movements of lions.

Often when I watched him rehearsing, Shaw struck me as more remarkable than the play itself. He always read the complete piece to the assembled company, giving just the right touch to each character which brought the whole thing alive to all concerned in the most vital manner. I shall never forget the Shaw rehearsals which

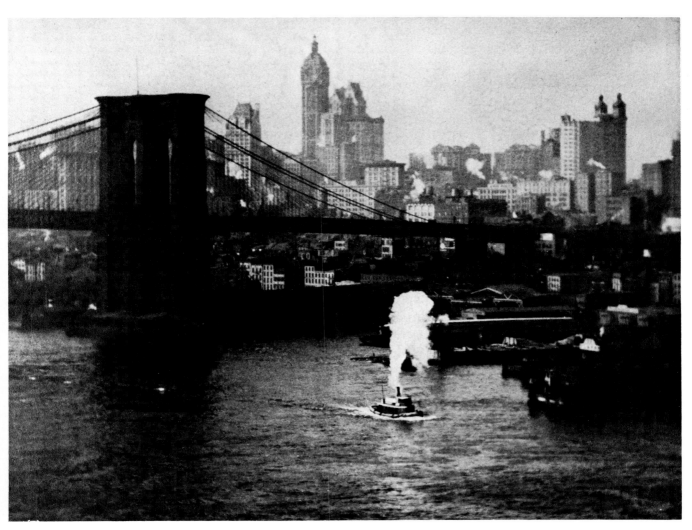

43. Brooklyn Bridge, New York. 1911

I attended, for they were most revealing and inspiring.

I made very many photographs of dress rehearsals, which resulted in some un-rehearsed thrills. On one occasion, not knowing that I was on the stage, where perhaps I should not have been, the scene-shifters began to "strike" the scene and I was nearly killed by a "wing" missing me by the narrowest margin! But it was a great life which I much enjoyed.

I remember my 1906 portraits of A. B. Walkley, the "Times" dramatic critic, who is ridiculed in the prologue and epilogue of *Fanny's First Play*, were used as a guide in making up the actor. G.B.S. wrote to me:

<div align="right">

10 Adelphi Terrace, W.C.
9th Feb. 1915

</div>

"Have you your old negatives of A. B. Walkley anywhere handy; and if so, could you let me have proofs from them, however rough?

Fanny's First Play is to be revived on Saturday next. At its original production I borrowed your fine prints from Walkley to cover the make up. I don't like bothering him again and again, and as the present representative of him is much more his build I don't want to copy the photographs of the old make up. So I bother you. I am rehearsing day and night, as I have to rush the production to keep the theatre going.

<div align="right">

G.B.S."

</div>

Immediately after the completion of *Men of Mark* I started on *More Men of Mark*, using my handier $3\frac{1}{4}'' \times 4\frac{1}{2}''$ reflex camera. The series began with a very peaceful and pleasant visit to Thomas Hardy, which included a stroll through the wide tree-lined streets of Dorchester, autumn-clad and gorgeous, to the Roman amphitheatre. It is strange how vivid certain memories can still be after a lapse of half a century. This walk through the rustling leaves (I have never grown up sufficiently to dislike shuffling through leaves) with the wise, kindly talk of my companion —could one desire more than this on an October day? I cannot remember what we talked about, and perhaps it does not matter much, but I carried away with me a camera full of negatives, an inscribed copy of *Tess*, and a feeling that my journey had not been in vain.

A little later, in December 1913, I made a portrait of Frank Harris, who as a teller of tales was unequalled. I have sat on the edge of a chair and listened with open-mouthed wonder at the most amazing yarns the mind of mortal man can conceive. He confided to me that in his life he would write three really great books. The first was about Napoleon, and that was finished; the second was to be about Christ; but the third, and greatest, was to be about Frank Harris!

At the end of 1913 a big dinner was held in London in honour of Anatole France. I sat just across the table from him, and so was able to make up my mind how I wanted to photograph him. Through the courtesy of the publisher John Lane I obtained a sitting, but it was a dull day and the exposures were of prodigious length. Sometimes this is not a disadvantage, for the result is often a composite of several fleeting expressions giving a true and characteristic blend. I made the portrait at Mr. Lane's house, on the landing of a staircase. My sitter was affable, and not at all

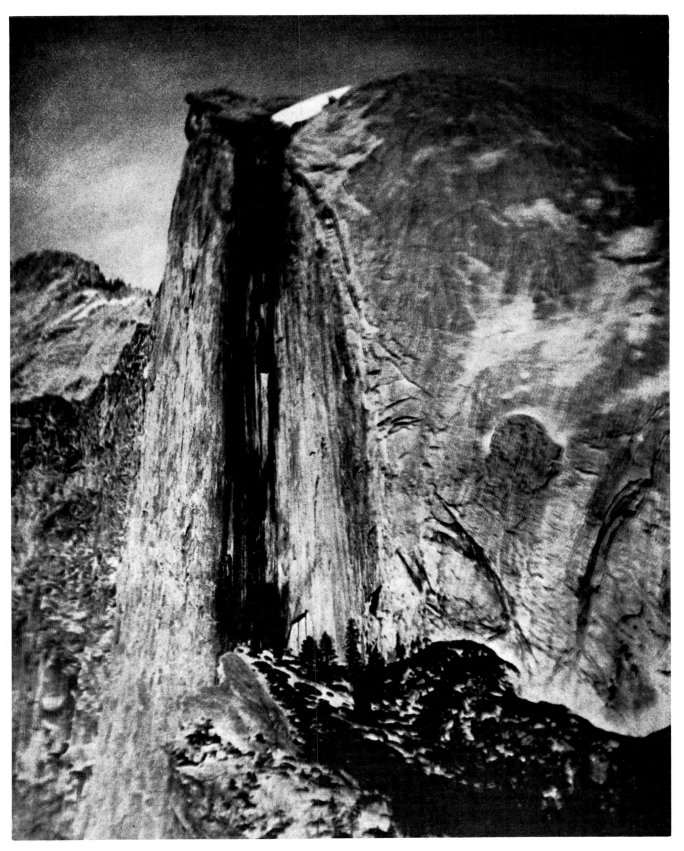

44. The Half Dome, Yosemite Valley. 1911

bored with the procedure. We were rather cramped for space, but this only added to the excitement of the adventure. There is a certain satisfaction in triumphing over the difficulties of any improvised studio which may be chanced upon. I have made portraits in offices, under trees, and in the wings of theatres, and great is the satisfaction of achieving the apparently impossible.

It was in the Temple that I went in quest of Israel Zangwill at this time, up one of those delightful old-world staircases in which this quaint corner of London abounds, to a room level with the tree-tops, where the distant rumble of the traffic in the Strand was only audible to the keenest ears. Here I spent a happy hour. It seems his play *The Melting Pot* was about to be produced, and Zangwill asked me if I would go and pass an opinion, as something of an expert, on the accuracy of a certain New York scene which was supposed to be on the top of a skyscraper. I did so, and made one or two suggestions which I believe were acted upon. And I almost forgot to mention—I took Zangwill's photograph.

When I read Compton Mackenzie's *Sinister Street* with its fascinating picture of my beloved London and its inhabitants, I was straightway filled with desire to portray with my camera the author of this work. What I remember best of Mackenzie is a taxi ride we took together in November 1914 through West Kensington, his own domain. The place became alive with the people of the story as we travelled through the gathering dusk, for Art is life and life is Art, and there is no difference in the twain, unless it be that they are the positive and negative aspects of the same great idea.

I had been an admirer of Maurice Maeterlinck for sixteen years before I photographed him, and had even made illustrations for the American edition of a little book of his, *The Intelligence of the Flowers*. When I heard in 1915 that he was coming to England, my excitement was unbounded. Fortunately I knew his hostess here, so it was possible to arrange for a sitting (Plate 25). The great Belgian writer did me the honour of calling upon me to collect his prints, and inscribed a copy of the book I had illustrated. Now I am not a collector of first editions—does a beautiful piece of prose or poetry wear out by repeated printings? Yet *inscribed* copies of books from their authors *do* seem to me to have that personal touch which brings romance into the realm of the concrete. I am a hero-worshipper, as I have often confessed! Why not admit the accusation at once? But my worshipping is not mere idle curiosity, it serves a useful purpose. And when in the days to come the historian of literature wishes to know how Maeterlinck looked—well, he will only have to go to the British Museum and get out my book.

In the spring of 1914 I was approached by John Masefield—whom I had portrayed in *Men of Mark*—to make a series of sailing ships. So on the first of May I went to Falmouth, Cornwall, with my wife and mother, to capture a series of these lovely subjects. Remembering having seen pictures of palm trees in Falmouth I took only summer clothes, which was a great mistake for it was very cold, especially at

45. Mount Wilson, California. 1911

sea, and I had to re-fit myself locally with warmer underwear.

In order to photograph ships under full sail I hired a tug-boat and went out to meet them every day for a week, before they had furled their sails to enter the harbour. Once I climbed right up into the rigging with my reflex camera lashed between my shoulders in order to get an unusual angle-shot of the deck from this birds'-eye vantage point. It was as well that I am not a bad sailor, for we experienced some rough weather.

The final result was several hundred negatives of which about fifty were worth printing. Seven of them were published in *Harper's Magazine* for Christmas 1914 with a poem by Masefield, who also wrote captions and descriptions of the illustrations.

I have always delighted in ships; they are wonderful things, steeped in romance, smelling of tar and tea from China and salt from all the quarters of the world. If I had waited until after the war there would have been very few sailing ships left, so I am grateful to Masefield for his suggestion. (Plate 53).

A little book which I am very happy to have made about this time was on Moor Park, the home of Lady Ebury, who was a pupil of mine in photography. I spent many happy days at this fine eighteenth-century house instructing her. The book was published by Elkin Mathews in 1914.

It was in 1914 that Wyndham Lewis (Plate 26) founded the *avant-garde* movement named by the American painter and writer Ezra Pound "Vorticist", the ideas of which derived partly from Futurism and partly from Cubism. I did not see why my own medium should lag behind modern art trends, so I aspired to make abstract pictures with the camera. For this purpose I devised the Vortoscope late in 1916. This instrument is composed of three mirrors fastened together in the form of a triangle, and resembling to a certain extent the Kaleidoscope—and I think many of us can remember the delight we experienced with this scientific toy. The mirrors acted as a prism splitting the image formed by the lens into segments. If anyone is curious as to its actual construction, I gave my original Vortoscope to the Royal Photographic Society, where I have no doubt it is still preserved. The objects I photographed were usually bits of wood and crystals—and in the case of Plate 55 Ezra Pound himself. Plate 54 is a typical Vortograph, but I made many more, all differing from each other and each possessing its own individual character and pattern. I think that to appreciate their variety a number of Vortographs have to be seen together, and I hope to publish some day a little book of these abstract photographs to prove my point. These intriguing combinations have for me an enduring fascination which increases with the passing of the years. Photography depends upon pattern for its attractiveness as well as upon quality of tone and luminosity, and in the Vortograph the design can be adjusted at will.

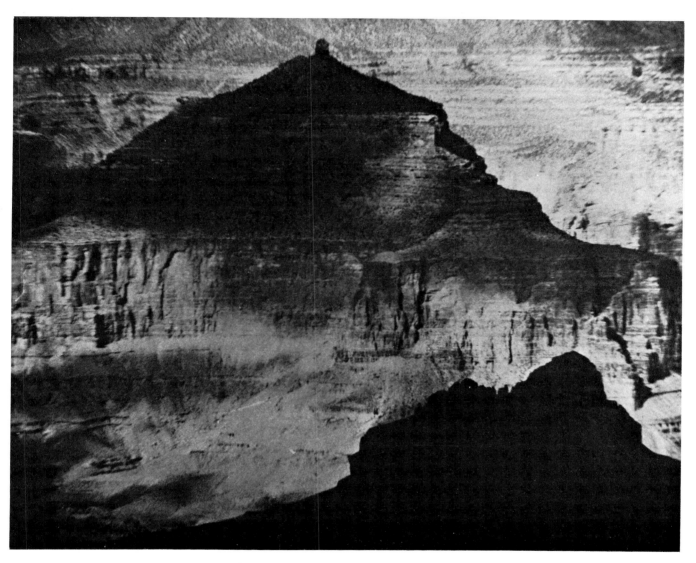

46. The Great Temple, Grand Canyon. 1911

X. Vortographs, the Pianola and Musicians

IT WAS IN JANUARY 1917 that I created these first purely abstract photographs. I was invited to hold a one-man show at the Camera Club in London the following month, and agreed on condition that I could hang whatever I liked. This was granted, and the exhibition consisted of thirteen of my paintings and eighteen Vortographs. Ezra Pound wrote an anonymous preface to the catalogue, which he acknowledged by printing a modified version of it in his book of essays *Pavannes and Divisions* the following year. The Vortoscope, he said, freed photography from the material limitations of depicting recognizable natural objects. By its use the photographer can create beautiful arrangements of form for their own sake, just as a musician does; but Pound warns that the Vortoscope is useless to a man with no eye for form or pattern. At the opening of the exhibition Pound elaborated on the theme of his preface, and Bernard Shaw contributed in his usual brilliant manner to make the evening memorable. Photographers inevitably did not know what to make of it all, and I was highly delighted at their confusion; but towards the end of the show they even began to like Vortographs with their strangely fascinating designs.

For the first decade of my career it was mostly writers and artists whom I portrayed. It was not until just before World War I that I began photographing musicians, though I had long been very interested in music, especially in connection with the Pianola. I have a theory that there is a certain relationship between the Pianola and the camera, for in each case the mechanical rendering frees the artist from certain technical difficulties so that he is able to concentrate on interpretation. My Pianola was specially constructed for me in April 1914, and as I often wanted modern music—Debussy, Ravel, Scriabin, Stravinsky—not commercially available, I sometimes cut rolls with a perforating machine made for me by a camera manufacturer. I was very interested in the patterns made by the holes punched in the paper and found that the patterns of Bach were especially beautiful. I also experimented with the sounds made by patterns conceived merely visually! I had in the end over a thousand music rolls, and was thus able to become familiar with, and render enjoyable to myself and others, a wide range of compositions, mostly modern.

The Pianola brought me in touch with many well-known musicians, and I played sonatas with famous violinists and also the solo part of a piano concerto with a symphony orchestra. But in January 1928 a distressing event ended my musical career. A very high tide breached the wall holding back the river and allowed three

47. The Temple of Ohm, Grand Canyon. 1911

feet of muddy water to flood "Thameside", destroying the Pianola and my entire library of music rolls. I tried to take the loss philosophically, telling myself that it was all for the best as music occupied too much of my time, and I was able to devote myself to other, and to me more vital concerns.

My wife and I often went to Promenade concerts, so it was fitting that the first photograph of this series was of Sir Henry Wood. He looked the typical famous conductor, with his piercing eyes, well-trimmed beard, and a fur collar to his overcoat. He was undoubtedly what one calls a personality, able to dominate and inspire his orchestra and his audience, yet with it all a very kind and human person. Sir Henry seemed to enjoy being photographed, and although he must often have stood before a camera he was not bored with the process but chatted affably with me, even making me feel that I was conferring a favour upon him in adding him to my collection of famous people.

It was at one of Sir Henry Wood's concerts that I first heard that inspiring and unique pianist Vladimir de Pachmann, and was thrilled by his genius. The evening before a sitting had been arranged for me to photograph Pachmann, I went to a recital he gave at the old Queen's Hall near what is now Broadcasting House, and sat on the platform to be as near as possible to the pianist in order to study him at close range. I noticed that while Pachmann played he kept looking at me, smiling and nodding his head. When I arrived at his studio the next morning, to my astonishment he rushed up and embraced me, exclaiming, "I played to *you* last evening!"

Pachmann was particularly celebrated for his interpretation of Chopin, but I, greatly daring, told him that I preferred his Bach. This pleased him enormously. "You like my Bach? I play you some Bach!" and sitting down at the piano forthwith, he gave me a recital of this great composer. How truly wonderful it is to be able thus to come into intimate personal contact with the great ones of our admiration! What else but photography would have made such a thing possible? How else would I have been able to have a world-famous pianist give me a personal recital in this intimate and delightful way?

When I took Pachmann some photographs at a later date and asked him to sign one for me, he said he would rather play a sonata than write his name, but nevertheless complied with my request in what looked like the handwriting of a schoolboy, which only goes to prove that we each have our limitations as well as our especial skills.

My next adventure was to photograph that impressive singer and actor Feodor Chaliapin, after seeing him in most of his great roles in the Russian Opera season then in full swing at Covent Garden. He was a difficult "lion" to capture, but when I finally succeeded in reaching his presence it seemed as if he had all the time in the world to place at my disposal. Chaliapin knew a little English and I a little French, and we got on famously. He was great in every possible way, both as an

48. "The Octopus", New York. 1912

actor and a musician; over six feet tall and with a commanding presence that came to meet you with a tremendous impact, yet calm and serene as though there were within him a vast reserve of power.

I made a large number of negatives, and when I took the prints for his acceptance Chaliapin was so pleased that he suggested I should make some photographs of him in his various roles in the Russian Opera that fateful summer of 1914, but war was suddenly declared, so to my great regret this never happened. I have however a treasured souvenir of our meeting in a signed photograph inscribed in Chaliapin's strong and characteristic handwriting: "Bravo et merci". The print I chose for him to sign (Plate 24) was a profile with the light gleaming on his golden hair; he was wearing a silk shirt and flowing black tie, like those of French artists of that period. This photograph is, as was the man, virile and dynamic.

Another of my subjects, Mark Hambourg, introduced me to the great Belgian violinist Eugène Ysaye, and as a result of this contact Edith and I were invited to a party at the Hambourgs' home, where these two with Cedric Sharp the cellist gave a wonderful rendering of a trio by Brahms.

Hambourg at home was a very different person from Hambourg on the concert platform. On the latter he dazzled his audience with his virtuosity, but at home he was quiet and restrained both in his music and as a perfect host.

When talented musicians play for their own pleasure something rarely beautiful is achieved as they blend their skill and inspiration in perfect harmony. They completely forget themselves in their music and the result is never to be forgotten, and exemplifies the truth that perfection in any art is achieved by total self-forgetfulness on the part of the artist.

Gustav Holst was a mystic, and very interested in astrology. His Symphonic Suite *The Planets*, composed in 1914, is an audible expression of this interest, and a musical description of the influence of the various planets on men and the universe. I was privileged to hear *The Planets* three years before its first public performance in 1919. Holst played it from manuscript on the organ at St. Paul's School, Hammersmith, where he was Professor of Music. At the time I photographed Holst his music was comparatively unknown, but it has since come into its own. He was a fine man, calm and reserved, and not easily to be known, but with much depth of character and profound mystical penetration.

I shall never forget photographing Sir Thomas Beecham in a room completely lined with little cupboards containing innumerable cigars, one of which he hospitably offered me when I had made my photographs. He seemed greatly disappointed when I said that I did not smoke, assuring me that I missed one of the supreme pleasures of life by abstaining!

My next sitter, in the autumn of 1916, was Sir Granville Bantock, who often came to Harlech when I later resided there, and we climbed many mountains together. In 1938 I wrote a play for children on a Druidal subject, entitled *Fairy*

49. "The House of a Thousand Windows", New York. 1912

Gold, for which Sir Granville composed some charming music. The play had its first performance at the Liverpool College for Girls at Huyton. I well remember Bantock coming there to play his music while I read the play to the assembled cast of children, all seated on the floor, wide-eyed in expectation. Their attitude was: "This is *our own* play, no one has ever performed it before."

I photographed Benno Moiseiwitsch also in 1916 (Plate 28). He and his wife for some time went regularly with Edith and me on Saturday afternoons to the cinema in Hammersmith to laugh at Charlie Chaplin and "Felix the Cat" in the good old days of the silent films. I even had the temerity to play the Pianola to Moiseiwitsch, who was quite astonished at what I could accomplish on it.

One afternoon when we were having tea with them the postman knocked, and a large score was unrolled and placed on the piano. It was a new piano concerto by Prokofief, and Moiseiwitsch straightway played it at sight from the score, the orchestral part as well as the solo. Only a fortnight later I heard him play this long and complicated work at a concert from memory—a truly remarkable feat by a great musician.

In 1918 I was privileged to photograph Jan Sibelius. Sir Granville Bantock arranged the sitting, for they were old friends and admirers of each other's music. For so famous a man Sibelius was very shy, and it was said that he disliked being photographed, but as Bantock came along to the sitting, after we three had lunched together, it all worked out very satisfactorily, for while they chatted I got on with my work.

Sibelius had one of the most powerful heads I have ever photographed (Plate 30). It was rather square and reminded me of a bust by Rodin. The great Finnish composer was very akin to his music—reserved, but with deep spiritual power, living within himself, yet sharing his dreams with us.

Five years ago in a B.B.C. broadcast entitled *Musicians in Focus* given in the interval of a Sunday symphony concert, I spoke of photographing Sibelius, and my talk was followed by a performance of his First Symphony.

Not long after Sibelius I photographed Frederick Delius, whose music was then only just beginning to be recognized. What do I remember of Delius after the passing of over forty-five years? The delicacy of his hands—true pianist's hands, with their long tapering fingers—and the strange other-worldly look on his face, as if, even in your presence, a new and very mysterious kind of music were forming itself in his mind.

Whenever I hear Delius's subtle music—and it is performed more and more frequently these days, I am glad to say—I remember with pleasure that day in 1919 when I met and photographed him.

The last of my series of musicians was Igor Stravinsky, of whom I was and remain a great admirer. I photographed him in 1921 in the middle of the morning in his dressing-gown, but there was nothing in the least sleepy or relaxed about him.

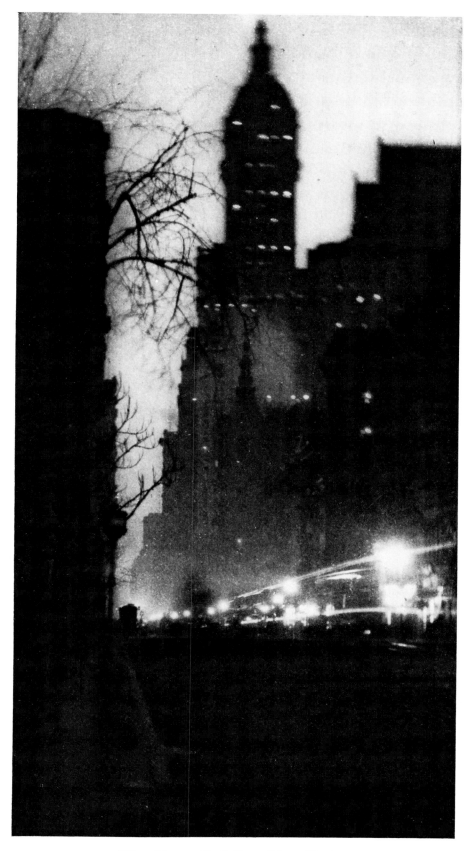

50. The Singer Building, New York. 1912

He was as alive and forceful as anyone I have ever photographed, and this is exemplified by the variety, vitality and scope of his music. My best portrait of Stravinsky (Plate 31) seems to be looking at you, taking your measure, and as it were ready to plough down upon you and overwhelm you, like the figurehead on the prow of a great ship as it cleaves the waves! This is the effect that his dynamic music has upon the listener. It cannot be heard with indifference, nor can Stravinsky himself be met and known with indifference.

In the course of seven years I made thirty-three portraits of musicians, which were intended for a book, *Musicians of Mark*, but up to the present most of them have remained in my portfolio. I enjoy going through them, for they bring back memories of those wonderful years when music was so happily woven into the pattern of my life.

As we grow older, and we trust a little wiser, it is very good to look back on the past and remember those we have met—especially those who have added beauty and joy to the world by the exercise of their art.

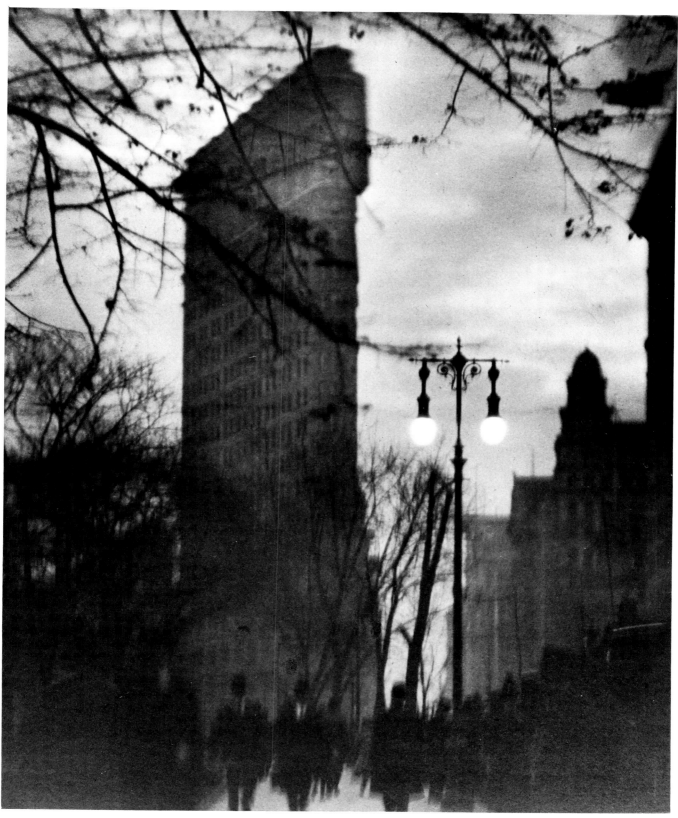

51. The Flat-Iron Building, New York. 1912

XI. Harlech, Freemasonry,
the Church in Wales and the Gorsedd

IT WAS IN THE SUMMER OF 1916 that Edith and I first came to Harlech in North Wales at the invitation of George Davison, managing director of the Kodak Company, whom I knew as a photographer of ability through serving with him on several photographic juries and committees. Davison lived in a large mansion called "Wernfawr", and also owned a number of cottages dotted about the estate, one of which he lent us for a holiday. We were both so charmed with the beauty of Harlech and the surrounding country that when the war was over in 1918 we bought a plot of land called "Cae Besi" (Elizabeth's Field) above the St. David's Hotel, and built a small house of local stone, under one of the first building permits to be issued after the war. Later we built a second house to lend to friends. We lived at Harlech for nearly thirty years, spending the winters only in Hammersmith until the death of my mother in 1928.

There was a beautiful large music room in "Wernfawr"—now Coleg Harlech—where Davison gave Sunday concerts at which he played on his automatic Aeolian organ and I on a Pianola. A number of the musicians I photographed took part in these concerts from time to time.

Just across the bay from Harlech was Criccieth, home of David Lloyd George. I was introduced to him at a charity concert given by my friend Cyril Scott, the composer and pianist, who arranged for me to go the next day, 25th August 1918, to have tea with the Prime Minister and photograph him (Plate 32). Lloyd George was a man of unusual personal magnetism. When he entered the room my back was turned, yet I immediately felt his presence! What is that quality which makes a man thus felt? Is it the same by which an orator holds his audience and sways the destinies of the world by the power of his speaking? Lloyd George was one of the most dynamic speakers I have ever heard. The day I was made an Ovate at the 1929 Eisteddfod I sat behind him on the platform in my green robes, and watched the vast crowd respond to the wonder of his voice. He had them under his spell, as a conductor holds his orchestra, and could do what he pleased with them.

At home, Lloyd George might have been just a quiet, simple country gentleman, for any fuss he made about himself. The war was just at its sharpest, all the earth was shaking with the thunder of it, yet he could sit and chat about the weather and feed the little dog with crumbs from the tea table as though he hadn't a care in the

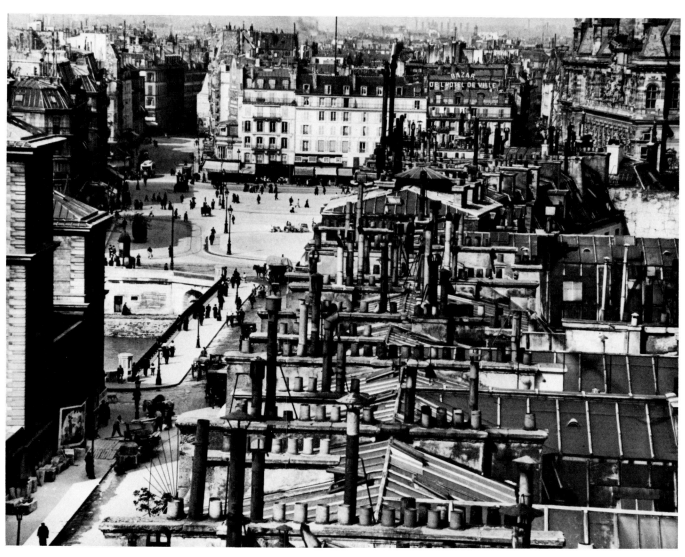

52. Roofs, Paris. 1913

world! Otherwise, perhaps he could not have stood the strain. I saw a very different man at 10 Downing Street, where I went at his suggestion to photograph Foch and Clemenceau! There Lloyd George was in the thick of things, with every ounce of his will and nerve-power keyed up to the highest tension; but I like to think of him best in the happier mood at his home in beautiful Wales.

Six months earlier it had taken me just five minutes to photograph his predecessor in office. H. H. Asquith sat looking out of the window of No. 10, and I believe he hardly noticed my presence! Such is the price of high office: every minute of your time arranged for you by secretaries for weeks in advance. You must attend dull dinners and even duller public functions, and be photographed on every conceivable occasion. No, it's much better to be nobody in particular, or even an irresponsible artist!

Though not involved in the Great War to the extent that every civilian was in the front line in World War II, it was nevertheless an experience that left a deep mark, and led to an intensified search for things of the spirit. On 18th June 1919, in the Province and District of North Wales, I became a Freemason, and with keen zest investigated the hidden mysteries of nature and science. This experience introduced me to an inner world of beauty and profundity which has been of the greatest satisfaction to me. I have always been an enthusiast in every occupation into which I have penetrated, and this quest has been no exception. I was not satisfied merely to taste externals, but was eager to participate deeply, and so I investigated, as far as I was able, its profound penetralia.

I became Inspector General, Thirty-third Degree, for North Wales, of the Ancient and Accepted Rite on 9th May 1946; Provincial Grand Master of the Mark Degree for North Wales on 4th January 1952; and a Grand Officer in the Craft (P.A.G.D.C.) on 27th April 1960. I have delivered about twenty lectures on Freemasonry and related subjects, which will be found in the *Transactions of the Manchester Association for Masonic Research*, *The Merseyside Association*, and other publications, by those qualified in this field of study.

An important event in my life was my appointment as Lay Reader in the Church in Wales. On 16th May 1935 I received a licence in the Diocese of Bangor from Archbishop Green, which was transferred to the St. Asaph Diocese under Bishop Havard when I came to live at Colwyn Bay in 1945. I found this work most congenial and satisfying, particularly when I was able to function in little country churches in need of my help.

For many years after retiring to the fastnesses of "Wild Wales" I did comparatively little photography, though I never entirely gave it up, for this is utterly impossible. Once the virus has entered the system it is there until time for us is no more. I sometimes climbed mountains as an excuse to use a camera on clouds, rocks, little lakes nestling in valleys overshadowed by the heights, and prehistoric stone monuments. There was, I may also mention, a small *Book of Harlech* published

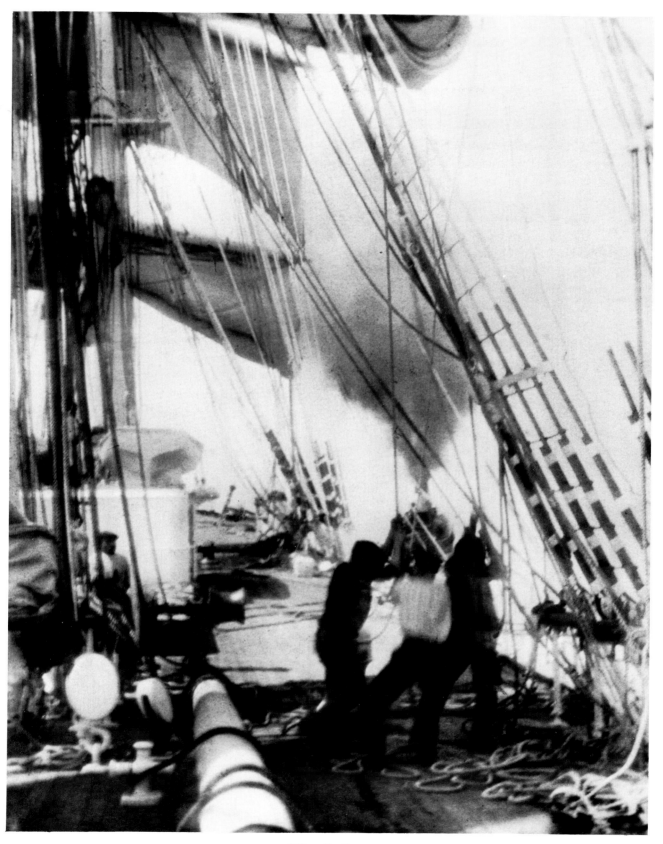

53. The Sully. 1914

locally in the town of my adoption in 1920, which bears testimony to my activities at that time.

In August 1927 I was made an Honorary Ovate of the Welsh Gorsedd, with the title of Mab-y-Trioedd (Son of the Triads) on the proposal of Sir Granville Bantock, the famous composer and adjudicator, which was seconded by Sir Vincent Evans, at that time the Secretary of the Honourable Society of Cymmrodorior. Of this I am very proud, for it seems to bring me close to Wales, my adopted country, which I very greatly love.

For a number of years I made photographs of the stages of construction of Liverpool Cathedral, both for my own pleasure and for the satisfaction of Dean Dwelley, who was responsible for watching over the building programme. From time to time I received in Harlech urgent, sometimes almost frantic, telegrams from the Dean to inform me that some particularly attractive piece of scaffolding or never-to-be-repeated bit of stonework simply *must* be photographed by me. So everything else was forgotten and I left in haste to perpetuate it. It was always a delightful adventure, but not always without danger, for the Dean had a way of sometimes leading me along high-up railless planks to points of photographic vantage only really properly accessible to the birds! We invariably finished with a delightful meal with the Dean and Chapter in a corrugated iron hut in the precincts. Plate 56 has in some measure the quality of a Vortograph, but there are hundreds more of these photographs of the various stages of the construction, which remind me of many happy days and congenial companionship.

54. Vortograph. 1917

XII. The Inner Life

In october 1923 I met a great and good man, who influenced my life more profoundly and changed it more completely than any other person I have ever known, and I am deeply grateful to Divine Providence for having placed this supreme experience in my path.

He seemed to know you more completely than you knew yourself, but never attempted to dominate your inner or your outward life, being concerned that you should always exercise your own freedom of choice. He was the perfect teacher, always ready to inspire and encourage, knowing exactly what you needed in the next step of your gradual spiritual growth, and imparting it with rare tact and discrimination. He also had the capacity to inspire love and devotion in those with whom he worked, and gave himself selflessly and without reserve.

This man was great in every possible way. Wise, discerning, keenly alive to true happiness, and giving you every encouragement to live up to the highest and noblest ideals. At our first meeting we went, I remember, to a Chinese restaurant in London for tea, and remained there talking eagerly about the things which matter most until the place closed at a late hour. Time just seemed to slip away as if we had moved on into eternity.

The whole of life became ordered and took on a new significance and purpose, which has remained with me up to the present day. I had lost nothing of my devotion to photography, it had just been changed, lifted up and orientated into another and more spiritual channel.

All art belongs to the same great Reality, but it is an ascending ladder, with earthly beauty at its lowest rung and Divine Beauty as its Crowning Glory, and in between them a sequence of ascent in perfect symmetry and order.

All this I was shown and very gradually came to understand.

Another man of extraordinary spiritual power who left a lasting impression on me was Professor D. T. Suzuki (Plate 29), the Zen Buddhist who came to London from Japan in 1936 to speak at the World's Congress of Faiths on "The Supreme Spiritual Ideal". He stood before a vast and enlightened audience, speaking in simple words of simple things in such a way that his own profundity became self-evident. Suzuki confessed that he really did not know very much about the Supreme Spiritual Ideal, for he was a very humble person who lived in a little straw-thatched house in the midst of a garden, and his mind having its setting in such simple surroundings, how was he to know about such mighty things? His approach

55. Vortograph of Ezra Pound. 1917

reminded me of the very wise old Chinese philosopher Lao-Tze, who said of the Supreme Tao, the Absolute God: "He who knows of It, tells it not; and he who tells of It, knows it not!"

It was not what Professor Suzuki *said* but what he *was* which impressed the audience so deeply, for it is simplicity itself and directness of approach which are always most profound. Zen Buddhism has this simple profundity, and many people in this complicated and over-materialistic age of ours are turning to its study to discover what it has to offer us.

I consider Suzuki one of the most remarkable men I have ever had before my lens, although it has looked at many who have been distinguished in their time and generation.

Friends have sometimes asked me why for many years I ceased to devote my energies exclusively to photography, after having attained a certain proficiency in it through a life of dedication to it. I think I can justify this change of occupation on the ground of ultimate values. Spiritual concerns are more important, and the art of the inner life is more vital and significant to the supreme and ultimate purpose of the human soul, than any other activity. If you compare photography and religious mysticism as alternatives to which one should devote one's life, can there be any doubt as to their respective importance?

The greater choice, however, always includes in some measure the lesser. Seek ye first the Kingdom of Heaven and all other things are added unto you, for religious mysticism is the peak of the range from which even the vistas of photography may be beheld in an ever newer, richer and more mysterious radiance.

Photography teaches its devotees how to look intelligently and appreciatively at the world, but religious mysticism introduces the soul to God.

56. Liverpool Cathedral under construction. 1919

XIII. Winters abroad

ON 24TH MAY 1932, having resided for almost twenty years in Britain, I decided to become a British subject. In this I followed the example of Henry James.

At the beginning of the second world war I joined the Red Cross and acted as Honorary Secretary of the Joint War Organisation of the Red Cross and the Order of St. John for the duration of hostilities. My wife was Commandant of the Harlech Detachment of the Red Cross and ran a small hospital for evacuated children with skin troubles in one of our own houses. As a result of her over-strenuous activities she became afflicted with serious heart trouble. Harlech was too hilly for her, so in 1945 we moved to Colwyn Bay, which is flatter.

Towards the end of Edith's life she could not stand damp, chilly weather and we had to winter abroad. First we went to the south of France, then to Pau in the Pyrenees, later to Gibraltar, and finally to Madeira, where photography burst forth once more in my life with all the old keenness.

To leave wintry Britain by flying-boat and land in the eternal summer of Madeira seemed miraculous. It is difficult to believe that here there is never any need for artificial heating, and that it is possible to bathe in the sea with comfort at all seasons.

This lovely volcanic island is only thirty-five miles long with a maximum width of thirteen miles, but the precipitous coast-line with many indented estuaries is ninety miles in length. The mountains leap up from sea-level to 6,000 feet, with unbelievable roads wonderfully graded and engineered. There is only one town, Funchal, which is also the only harbour, and here the tourists chiefly stay. Not far along the coast is the picturesque fishing village Camera de Lobos, the haunt of artists, where Plate 58 was taken, with its curious nets by which the sun is partly veiled.

The inhabitants of Madeira, mainly of Portuguese descent, are poor but seem very contented. Their chief occupations are fishing, growing vines, sugar-cane, fruit and vegetables, and the manufacture of baskets (Plate 60) from the osiers which grow in profusion in the marshes. They are woven by hand with great skill and speed on a kind of framework and dried in the sun (Plate 59). Thousands of the women make lace and embroidery, an industry started by an Englishwoman about a hundred years ago.

Most of the cottages are thatched and have earthen floors, and nearly all the people go barefoot. Their diet consists largely of home-grown vegetables—mostly cabbages—with a little fish on Sundays and festivals.

57. Undefeated. 1953

One of the pleasant recreations of the people of Madeira is to go from one village to another on the innumerable saints' days. Each village has at least one patron saint, some have several. Many villages can only be reached by a rough footpath, or by following the *levadas* or watercourses, but this does not deter their inhabitants from attending these celebrations in their gayest holiday attire. Vast quantities of fireworks are discharged, and local bands play, not always too proficiently. It does not matter greatly so long as there is plenty of noise! The religious side is not neglected for the people are very devout. Even in the smallest places there are quite big and elaborately decorated churches, much too large, be it said, for the local population.

The method of irrigation is by an elaborate system of *levadas* or narrow open stone-lined aqueducts which run along the hillsides, turning arid valleys into fruitfulness. Every hillside is skilfully terraced, and the soil with its plentiful supply of lava is very fertile for vineyards. Madeira is fertile also for photography, and I was never happier in this respect in any place I have ever been to.

During our first visit to Madeira in the winter of 1954-55 I made about three hundred exposures, and my joy at getting into my stride again, photographically, knew no bounds. When we went out again for the winter of 1955-56 I thought I had practically exhausted the possibilities of the island and very nearly left my camera at home, but I was completely wrong. Familiarity with Madeira does *not* breed contempt—I made another three hundred exposures, with different, better, and more interesting results than those of the previous winter. As with a good and trusted friend, the more you come to know him or her the greater and more discriminating is your love. So it was with Madeira. In the first year I had chiefly photographed the obvious beauties that tourists admire, but did not really come to know the real Madeira.

And what of the third winter, that of 1956-57? Could I expect to discover anything further in the rich bounty of this lovely island? And the answer was yes, and again, yes! Another three hundred negatives revealed still more novel subjects, for I penetrated by means of a newly excavated tunnel through previously inaccessible mountains into a region resembling the Mountains of the Moon.

I have come to the conclusion that the better you know a place the more you can find in it to photograph. One remembers how Claude Monet painted over and over again the same haystack in the same field at different hours of the day, and how he rented a room opposite the façade of Rouen Cathedral so that he might paint it in every gradation of light and shadow. This repetitional aspect of a subject, to get it in its most perfect lighting, is an exercise in patience and discrimination in which the photographer has to give himself a special form of training. The movement of a cloud's shadow across a landscape makes all the difference. You see the wonderful thing happen, but perhaps you have not the time to get your camera out to snare it, and so you wait patiently—or even impatiently, in any event, you wait—until the miracle repeats itself.

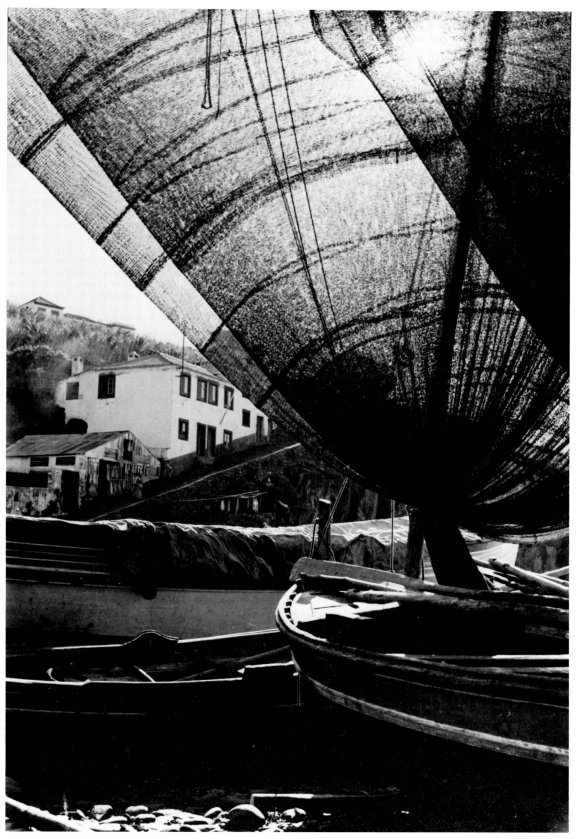

58. Fishing-nets, Madeira. 1953

XIV. Conclusion

THE STUDY OF A TREE-TRUNK which I entitled "Undefeated" (Plate 57) was made in 1953 at Edstone near Stratford-on-Avon at a delightful place for the restoration of health. Trees are wonderful things, their beauty is limitless in its variety, and there is, I understand, a society known as "Men of the Trees", who have made records of their serenity and charm.

Photography has an especial capacity for recording the splendour of these natural perfections, but this one was chosen for its tenacity. Life refuses to be extinguished, and even as the soul is immortal, so there is something in the world of nature, which seems to live on and perpetuate itself in a truly remarkable way. The circle of the perpetuity of nature is an endless round of birth, maturity and death, but from the death of the seed and its burial in the earth comes a rebirth.

"Tree Interior" (Plate 62) was made in a lovely little Welsh valley at Llanarmon, near Chirk, where I spent the last holiday with my beloved wife before she passed into the Great Beyond in 1957. Perhaps it may be for this reason that I particularly cherish it, but it has its own especial beauty. The photograph was several days in the making. Each day I went and studied the tree, watched the sun travel over it and lovingly caress its uneven surfaces, to be sure that the most perfect rendering was secured. I think the things we ponder deeply and let sink into our consciousness, and really earn, are always more fully appreciated than those which come too easily.

My dear wife suffered much physically at the end of her life with patient resignation, and she was not afraid to face the Great Beyond. My thoughts are always with her in the most real way.

Our house "Awen"—which in Welsh means Inspiration—is really much too big now for only two people, my housekeeper Mrs. Sarah Riddle and myself, but I have over five thousand books, mostly on mystical subjects and Freemasonry. They line the walls from floor to ceiling in many of the rooms, and could not be accommodated in a flat. These books are great friends and I would not be without them, so I live on here at Colwyn Bay quietly content and deeply considering the mysteries of life, and what a wonderful world we live in, and how remarkable is the Divine Plan, and my joy is very great. I do not believe in Death, for my soul is ever in loving communion with Edith's, and will remain so through all eternity.

However externally restricting advancing age may be, it has many compensations. White hair inspires deference, and I remember with pleasure the first time I was addressed as "Sir"! But the chief reward of well-earned maturity is the

128

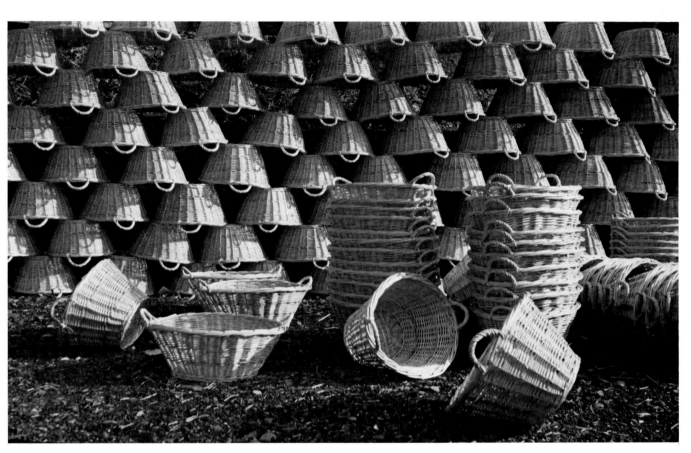

59. Baskets, Madeira. 1955

acquired capacity to look at life philosophically—to stand aside and observe one's own life as though it were the life of another, and above all to put first things first—and first things are always spiritual.

In connection with photography I have still experienced a few events of importance to me. Shortly after Edith's passing I opened a one-man show at the Royal Photographic Society in October 1957 to celebrate my fifty years' membership of the Society, which had made me an Honorary Fellow in 1931.

Another one-man show was held at Reading University in 1962. It came about in a curious way. Professor D. J. Gordon was collecting portraits for an exhibition on W. B. Yeats. Having seen one by me in a volume published in 1909 he telephoned the photo-historian Helmut Gernsheim and asked: "Where can I find the photograph of Yeats by Alvin Langdon Coburn?" My friend Gernsheim laughed and said: "The easiest thing to do is to ask Mr. Coburn himself", and gave him my address. Professor Gordon was quite struck by the simplicity of the solution and rang me up at Colwyn Bay. This contact led to the largest exhibition I ever had, and the first of its kind at a British University.

The following summer my good friend Norman Hall, the photographic editor of *The Times*, and I were invited to visit that distinguished American photographer Paul Strand and his wife, who live at Orgeval not far from Paris. I had not been abroad since the passing of my wife six years previously, and as Norman intended to go by car, the temptation was not to be resisted. So on 28th September 1963 we departed from London and arrived that evening at the charmingly hospitable home of our host. The autumn weather was perfect, the crossing by car-ferry pleasantly uneventful, and our welcome by the Strands had to be experienced to be fully appreciated.

Photographers are a friendly fraternity. They seem to be drawn together by their devotion to their work. It is a kind of dedication which breaks down the barriers of every day. When we meet it is as if we create a special kind of friendship which appears to have been always there.

Paul and Hazel had visited us at "Awen" during the lifetime of my sweetheart, and later I had met them in London under the intelligent hospitality of Norman Hall, who knows so well how to make already happy people happier still. This week in France completed the cementing of our mutual friendships.

Norman and I arrived at Orgeval on the Saturday evening, on Sunday we visited Versailles, on Monday feasted our eyes on Chartres Cathedral and the glory of its stained glass and Romanesque sculpture, on Tuesday we went to Paris where I renewed my friendship with Notre Dame. Every evening we had the pleasure of looking through Paul's beautiful photographs, than which no more perfect examples of our art exist. Also Hazel's culinary capacities belong to the supreme perfections of life.

On our return journey time seemed quite overpassed, for we crossed the Channel

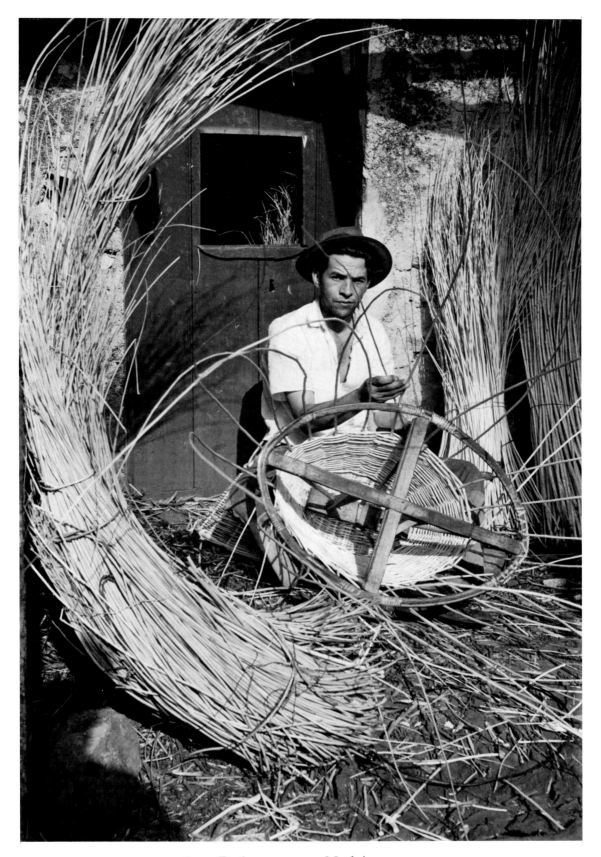

60. Basket-weaver, Madeira. 1955

with the car in a plane in about fifteen minutes, and so came to the end of this memorable visit.

Another contemporary American photographer whom I greatly admire is Ansel Adams. I have never met him but I have seen the first volume of his fine book *The Eloquent Light* with its inspiring text by Nancy Newhall, and feel I know him through his work. Some day I hope that I may shake hands with Ansel Adams, but even if I never do, I honour him as a fellow-worker of rare talent and supreme integrity.

"Reflections" (Plate 63) taken in 1962, is one of the most recent of my photographs. Perhaps it is a little difficult to discover what it represents. It is mysterious, as reflections are, until you appreciate that they are semblances of something more real, more spiritual. So I will not tell you what it is, but let your inner vision of its pattern guide you to its hidden mystery.

The winter following my visit to Paul Strand was the coldest for many decades. The sea at Colwyn Bay was frozen for the first time in living memory. I hastened to record it (Plate 64) and the simple beauty of its pattern pleased me greatly. Its calm serenity satisfies the soul by its indrawn stillness.

The simplest things are often the most profound, and the people who are able to achieve happiness in simplicity are usually the most serene.

Towards the end of life when its restlessness is stilled and the soul is drawn inward towards its own centre, there arises a peace which is very satisfying. Photographs of the calmness of nature in her more serene moods may have something of this same indrawn quality.

Now I have come to the end of the story of my photographic adventures, but life itself has been a never-ending adventure for me, and although I may have been at times addicted to the erection of castles in the air, I have always been brought back to earth by the mechanical nature of my medium. You may dream as much as you like before nature, but when you come to make an exposure you must think, to a certain extent, in the definite terms of science, and above all, in the dark-room a man who dreams is apt to have a rude awakening!

In photography, we turn outward to the appreciation and recording of physical things—and how wonderfully exciting they are, photography continually teaches us to appreciate. Yet, behind the ever-changing wonder of the material world there abides, immutable and serene, an Eternal Force which is its Cause, and the guarantor of its perfection. We cannot photograph this, but if we can glimpse it with the eyes of the soul, life is changed for us, for the manifested earthly greatness will unfold itself with a deeper significance. The greatest artists have always had a spiritual background, and I venture to suggest that a photographer will not be less proficient in his work if he sees in his subject matter the Master Workmanship of a Divine Creator.

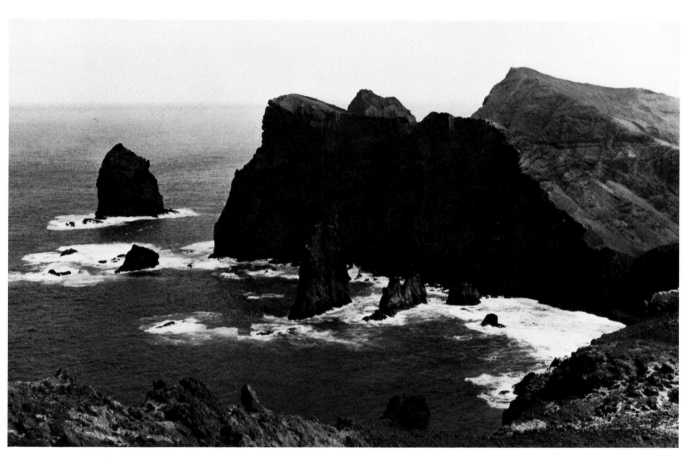

61. Canical, Madeira. 1957

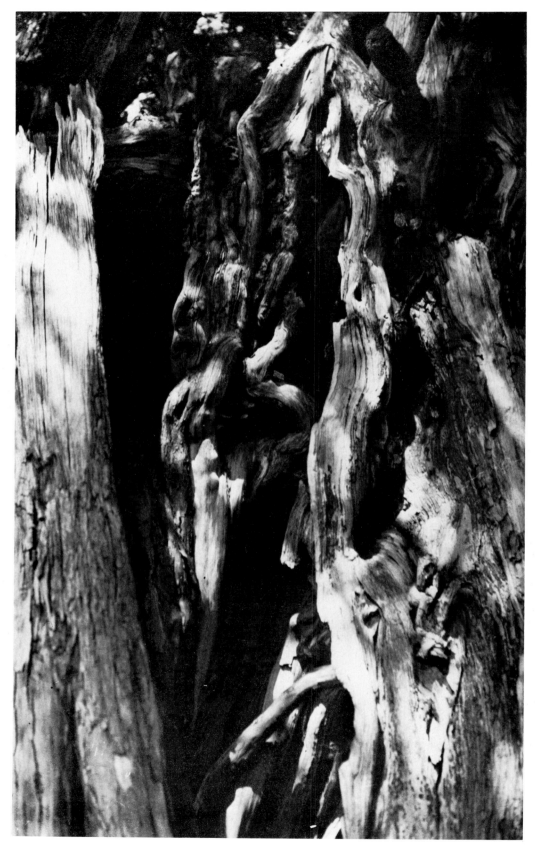

62. Tree Interior. 1957

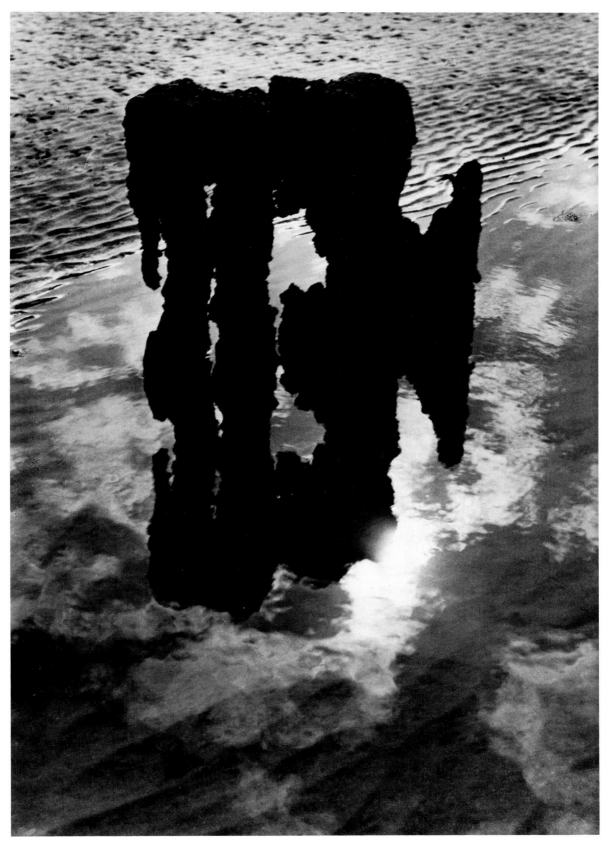

63. Reflections. 1962

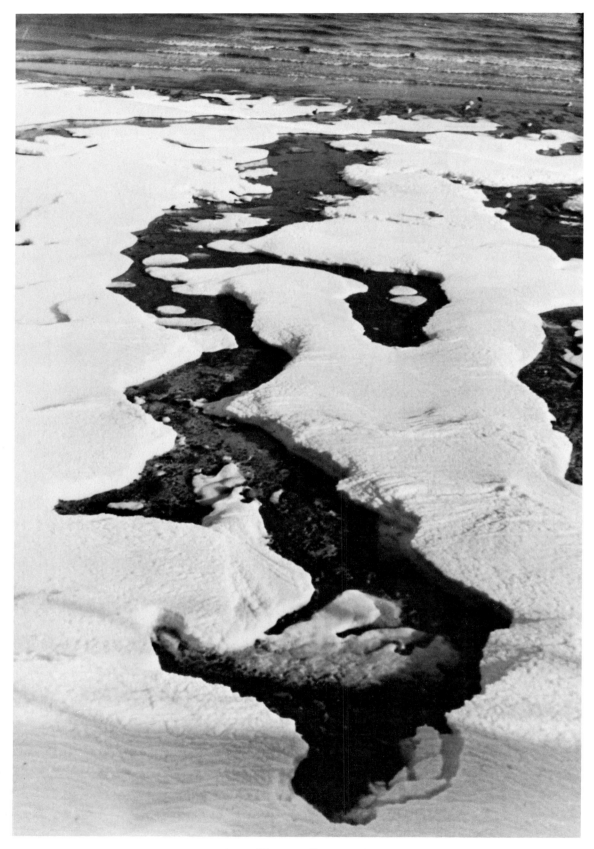

64. Frozen Sea. 1964

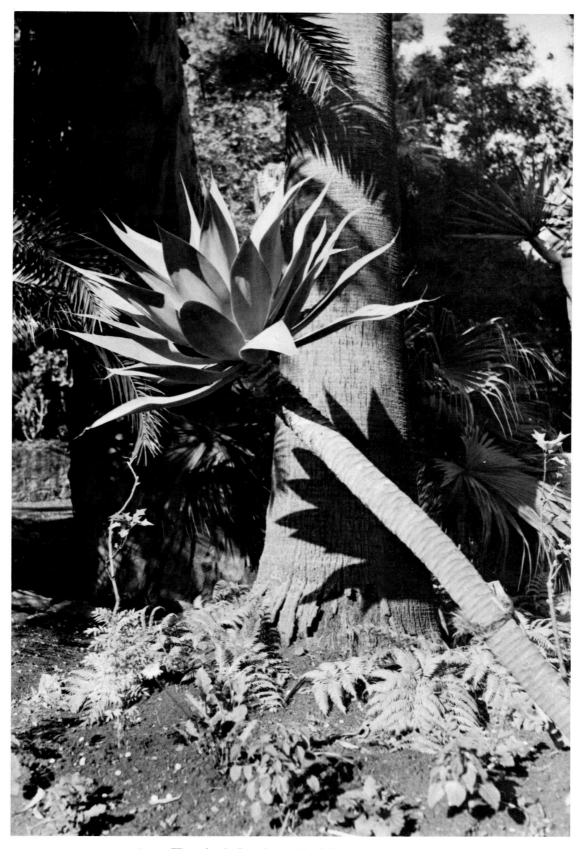

65. Tropical Garden, Madeira. 1954

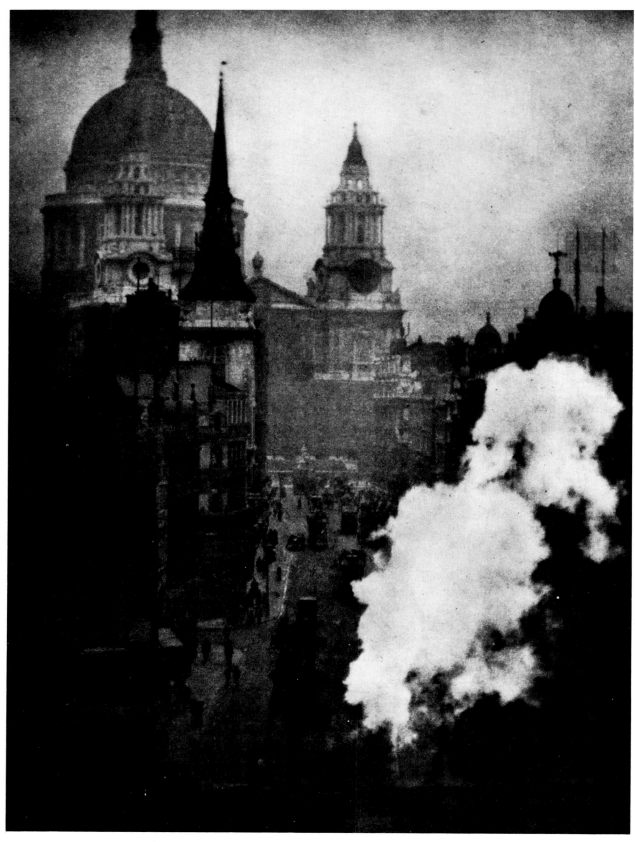

66. St. Paul's, London. 1908

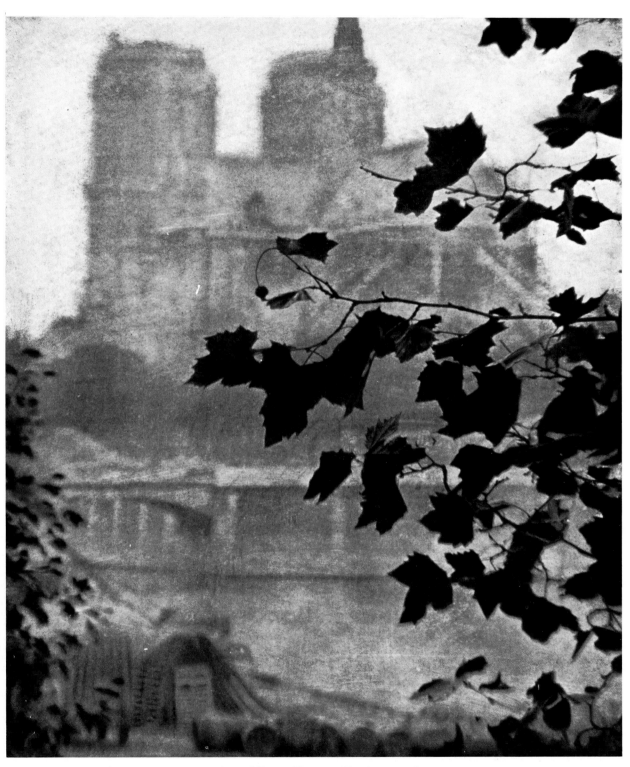

67. Notre Dame, Paris. 1906

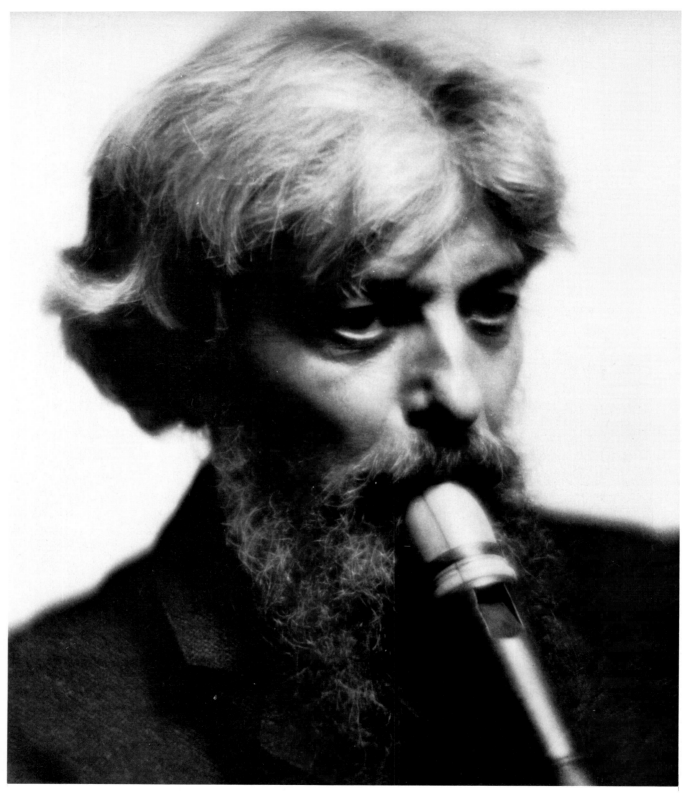

68. Arnold Dolmetsch. 1916

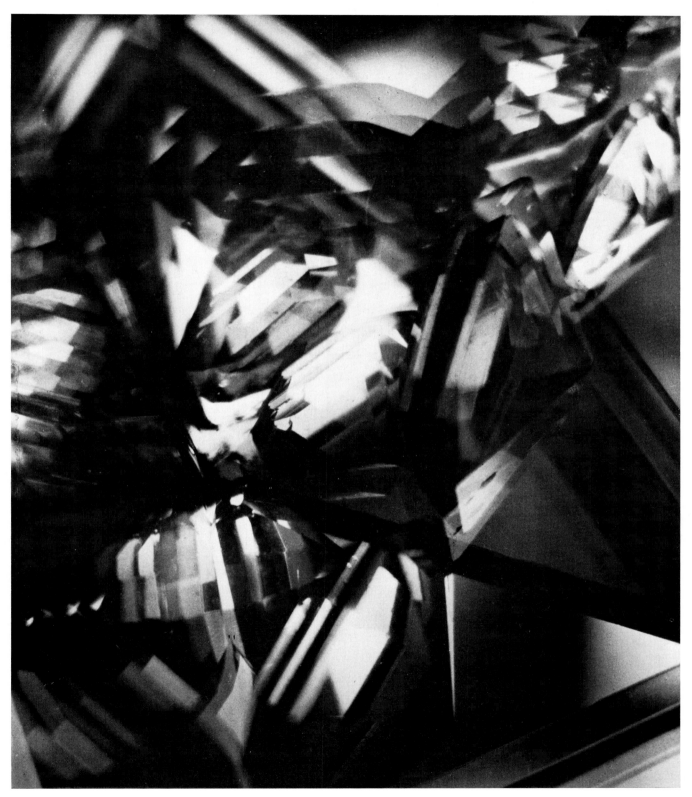

69. Vortograph. 1917

BIBLIOGRAPHY

BOOKS ILLUSTRATED WITH PHOTOGRAPHS BY ALVIN LANGDON COBURN

Fox, Minnie C. *The Blue Grass Cook Book* ($7\frac{1}{2}'' \times 5''$). With an introduction by John Fox Jr. Illustrated with thirteen photographs printed in halftone. New York: Fox Duffield & Co. 1904.

James, Henry. *The Novels and Tales of Henry James* ($9'' \times 6''$). London: Macmillan & Co. 1907-1909. New York: Charles Scribner & Sons. 1908. Twenty-four volumes each with a frontispiece photograph printed in photogravure. In the preface to *The Golden Bowl* (Vol. 23, page ix) the author comments on the frontispieces.

Maeterlinck, Maurice. *The Intelligence of the Flowers* ($8'' \times 5''$). Translated by Alexander Teixeira de Mattos. New York: Dodd, Mead & Co. 1907. Illustrated with four photographs printed in photogravure.

Nevill, Ralph and Jerringham, Charles Edward. *Piccadilly to Pall Mall* ($9'' \times 6''$). London: Duckworth & Co. 1908. Illustrated with two photographs printed in photogravure.

Coburn, Alvin Langdon. *London* ($16'' \times 12''$), with an essay by Hilaire Belloc. London: Duckworth & Co. 1909. New York: Brentano's. Twenty original photogravures, the first from Coburn's press.

Henderson, Archibald. *Mark Twain* ($8\frac{1}{2}'' \times 6''$). London: Duckworth & Co. 1910. New York: Frederick K. Stokes & Co. 1911. Illustrated with ten photographs of Mark Twain and his home, two in colour from Autochromes, printed in halftone.

Coburn, Alvin Langdon. *New York* ($16'' \times 12''$), with a foreword by H. G. Wells. London: Duckworth & Co. n.d. (1910). New York: Brentano's. Twenty original photogravures from Coburn's press.

Wells, H. G. *The Door in the Wall and Other Stories* ($15'' \times 11''$). New York: Mitchell Kennerley. 1911. Grant Richards, London. Illustrated with ten original photogravures from Coburn's press. Edition limited to 600 copies, 60 of which have title-page of Grant Richards and were signed by Wells and Coburn.

Shelley, Percy Bysshe. *The Cloud* ($13'' \times 9\frac{1}{2}''$). With six original platinotype prints of clouds. Los Angeles: C. C. Parker, privately printed limited edition. 1912.

Coburn, Alvin Langdon. *Men of Mark* ($12'' \times 9''$). Thirty-three original photogravures from Coburn's press, and text by him. London: Duckworth & Co. 1913. New York: Mitchell Kennerley.

Coburn, Alvin Langdon. *Moor Park* [Rickmansworth]. *A series of [20] photographs with an introduction by Lady Ebury. Limited edition.* ($9'' \times 7''$). The photographs are printed in photogravure. London: Elkin Mathews. 1913. New York: Charles Scribner & Sons.

Chesterton, G. K. *London* ($9'' \times 6''$). Illustrated with ten photographs printed in photogravure. London: privately printed 1914. "For Alvin Langdon Coburn and Edmund D. Brookes and their friends."

Coburn, Alvin Langdon. *The Book of Harlech* ($9'' \times 7''$). Twenty photographs printed in photogravure and text by Coburn. Harlech: D. H. Parry. 1920.

Coburn, Alvin Langdon. *More Men of Mark* ($12'' \times 9''$). London: Duckworth & Co. 1922. Thirty-three photographs printed in collotype, and text by Coburn.

Stevenson, Robert Louis. *Edinburgh, Picturesque Notes* ($10'' \times 7''$). With a preface by Janet Adam Smith. Twenty-three photographs printed in photogravure. London: Rupert Hart-Davis. 1954.

Newhall, Nancy. *Alvin Langdon Coburn*. Portfolio ($14'' \times 11''$) of sixteen photographs printed in collotype, with text by Nancy Newhall. Rochester, New York: George Eastman House. 1962.

Gruber, L. Fritz. *Grosse Photographen unseres Jahrhunderts*. (Great Photographers of our Century). ($13'' \times 10''$). The illustrations include seven by Coburn. Berlin, Darmstadt, Vienna: Deutsche Buch-Gemeinschaft. 1964.

MISCELLANEOUS WRITINGS OF ALVIN LANGDON COBURN

"Ozotype: a Few Notes on a New Process". *Photo-Era*, August 1900, p. 33.

"My Best Picture". *Photographic News*, Feb. 1, 1907, p. 82-84.

"Men of Mark". *Forum*, Vol. 50, 1913, p. 653-659.

"Alvin Langdon Coburn, Artist-Photographer, by Himself". *Pall Mall Magazine*, Vol. 51, 1913, p. 757-763.

"Photogravure". *Platinum Print*, Vol. 1, No. 1, Oct. 1913, p. 1-5.

"British Pictorial Photography". *Platinum Print*, Vol. 1, No. 7. Feb. 1915, p. 7-10.

Preface to catalogue of an exhibition of the Old Masters of Photography arranged by Alvin Langdon Coburn at the Albright Art Gallery, Buffalo, N.Y. Jan. 20-Feb. 28, 1915.

"The Old Masters of Photography". *Century Magazine*, Vol. 90, Oct. 1915.

"The Future of Pictorial Photography". *Photograms of the Year* 1916, p. 23-24.

"Astrological Portraiture". *The Photographic Journal*, Vol. 63, 1923, p. 50-52.

"Photography and the Quest of Beauty". *The Photographic Journal*, Vol. 64, 1924, p. 159-165.

Fairy Gold, A Play for Children and Grown-ups Who have not Grown Up (10" × 8"). With music by Sir Granville Bantock. London: W. Paxton & Co. Ltd. 1938.

"Bernard Shaw, Photographer". *Photoguide Magazine*, Dec. 1950, p. 10-17.

"Frederick H. Evans". *Image*. Vol. 2, 1953, p. 58-59.

"Illustrating Henry James by Photography". Radio talk broadcast by the British Broadcasting Corporation, July 17 and July 24, 1953.

"Two Visits to Mark Twain". Radio talk broadcast by the British Broadcasting Corporation, Sept. 23, 1953 and Jan. 1, 1955.

"Photographing George Meredith". Radio talk broadcast by the British Broadcasting Corporation, April 22, 1958. Published in *The Listener*, May 1, 1958, p. 731-732.

"Retrospect". *The Photographic Journal*, Vol. 98, 1958, p. 34-40.

"Musicians in Focus". Radio talk broadcast by the British Broadcasting Corporation, July 17, 1960.

"Photographic Adventures". *The Photographic Journal*, Vol. 102, 1962, p. 150-158. (Lecture at opening of Coburn's exhibition at the University of Reading, Jan. 23, 1962.)

ARTICLES CONCERNING ALVIN LANGDON COBURN

"American Photographs in London". *Photo-Era*, Jan. 1901, p. 209-215.

Cummings, T. H. "Some Photographs by Alvin Langdon Coburn". *Photo-Era*, Vol. 10, 1903, p. 87-92.

Allan, Sidney. "A New Departure in Photography". *The Lamp*, Vol. 28, 1904, p. 19-25.

Allan, Sidney. "The Exhibition of the Photo-Secession". *Photographic Times-Bulletin*, Vol. 36, 1904, p. 100-101.

Camera Work, No. 6, April 1904 contains six reproductions of photographs by Coburn and a critical essay by Charles H. Caffin.

Rice, H. L. "The Work of Alvin Langdon Coburn". *The Photographer*, Vol. 1, 1904, p. 132-133.

Hoppé, E. O. "Alvin Langdon Coburn". *Photographische Rundschau*, 1906, p. 175-178, with 17 reproductions.

"The Work of Alvin Langdon Coburn". *Photography*, Feb. 13, 1906.

Shaw, George Bernard. Preface to catalogue of Coburn's exhibition at the Royal Photographic Society, Feb. 5-March 31, 1906, and the Liverpool Amateur Photographic Association, April 30-May 14, 1906.

Camera Work, No. 15, July 1906 contains five reproductions of Coburn's photographs and a reprint of Shaw's preface to the catalogue of Coburn's exhibition in London and Liverpool, 1906.

"The Function of the Camera". *Liverpool Courier*, May 16, 1906 (review of exhibition). Reprinted in *The Amateur Photographer*, May 29, 1906, p. 447-448.

Edgerton, Giles. "Photography as One of the Fine Arts; the Camera Pictures of Alvin Langdon Coburn as a Vindication of this Statement". *The Craftsman*, Vol. 12, 1907, p. 394-403.

Camera Work, No. 21, Jan. 1908, contains twelve reproductions of photographs by Coburn.

"Artists of the Lens; the International Exhibition of Pictorial Photography in Buffalo". *Harper's Weekly*, Nov. 26, 1910, p. 10-11.

"Camera Pictures by Alvin Langdon Coburn". Catalogue of Coburn's exhibition at the Goupil Gallery, London, October 1913, with introductions by W. Howe Downes and A. L. Coburn.

"Vortographs and Paintings by Alvin Langdon Coburn". Catalogue of Coburn's exhibition at the Camera Club, London, Feb. 1917. With an unsigned essay by Ezra Pound and postscript by Coburn.

Guest, Antony. "A. L. Coburn's Vortographs". *Photo-Era*, Vol. 28, 1917, p. 227-228.

Pound, Ezra. "Vortographs", Appendix IV in *Pavannes and Divisions*, 1918. (Revision of his essay in the catalogue of Coburn's 1917 exhibition at the Camera Club, London.)

Johnston, J. Dudley. "Phases in the Development of Pictorial Photography in Britain and America". *The Photographic Journal*, Vol. 63, 1923, p. 568-582.

Firebaugh, Joseph J. "Coburn: Henry James's Photographer". *American Quarterly*, Vol. 7, 1955, p. 215-233.

Doty, Robert M. *Photo-Secession: Photography as a Fine Art*. Foreword by Beaumont Newhall. Rochester, N.Y.: George Eastman House. 1960.

Hall, Norman. "Alvin Langdon Coburn". *Photography*, Vol. 16, No. 10. October 1961, p. 32-41.

"Alvin Langdon Coburn". *Contemporary Photography*, Vol. 2, No. 1, summer 1961. A selection of photographs and a reprint of George Bernard Shaw's preface to Coburn's 1906 exhibition at the Royal Photographic Society.

Gruber, L. Fritz. "Ueber einen Fotografen, Alvin Langdon Coburn". *Foto Magazin*, April 1962, p. 48-51.

Index